IMAGES
of America

JEWISH COMMUNITY
OF LONG ISLAND

D1088481

IMAGES
of America

JEWISH COMMUNITY
OF LONG ISLAND

Rhoda Miller and the
Jewish Genealogy Society of Long Island
Foreword by Congressman Steve Israel

ARCADIA
PUBLISHING

Published by Arcadia Publishing
Charleston, South Carolina

Printed in the United States of America

Library of Congress Control Number: 2015955187

For all general information, please contact Arcadia Publishing:
Telephone 843-853-2070
Fax 843-853-0044
E-mail sales@arcadiapublishing.com
For customer service and orders:
Toll-Free 1-888-313-2665

Visit us on the Internet at www.arcadiapublishing.com

*This work is dedicated to Jewish genealogists,
whose research efforts ensure that the memory of our
ancestors will stay alive for generations to come.*

CONTENTS

FOREWORD

On Hicksville Road in North Massapequa, Long Island, there was a tiny house, almost lost among retail centers and takeout restaurants and pizza places. Decades ago, it was the Hillel Hebrew Academy. It's where I learned to read Torah and devoured Jewish history. It's where I celebrated my bar mitzvah.

The Hillel Hebrew Academy no longer occupies that house. But Jewish life and culture has indelibly and richly marked Long Island—from the small community of Jewish factory workers who settled in Sag Harbor in the late nineteenth century, to the new community of Persian immigrants who arrived in Great Neck in the late twentieth century. Jewish history is Long Island history, infused with our families and values; shaped by our synagogues, our schools, our Jewish community centers, and yes, our delis.

On my walls in Washington, DC, I display photographs of two of my grandparents, taken just as they arrived in America. I love studying those pictures. Myron and Rae Kass fled poverty, persecution, and pogroms in Russia. They crossed an ocean, settled in Brooklyn, and ultimately moved to Nassau County. I can still imagine the sharp smell of my grandmother's homemade gefilte fish, the warmth of seders in Bellmore, the snippets of Yiddish. My grandparents died many years ago; their photographs are my daily reminder of where I came from. I don't think my grandparents ever thought their pictures would be displayed in the US Capitol, in the office of a grandson with the title "Congressman." But they must have believed that if that was possible anywhere, it was only possible in America.

Those pictures tell a story of hope and hard work, of faith and opportunity. So do the pictures in this book.

—Congressman Steve Israel

Congressman Israel wrote the critically acclaimed comic novel The Global War On Morris, *which portrays Jewish life on Long Island.*

ACKNOWLEDGMENTS

Many people made this book possible. With much gratitude, we thank Congressman Steve Israel for his meaningful foreword. Sincere appreciation goes to Devorah Wang, president of the Jewish Genealogy Society of Long Island (JGSLI), for her thoughtful leadership and guidance throughout this project. The assistance of the JGSLI board of directors is gratefully acknowledged, with particular appreciation to Ann Armoza, Fern Gutman, and Renee Steinig. The generous support from Jay Miller, Cindy Korman Hodkin, and Fern Resmovits is much appreciated. Our Arcadia editor, Henry Clougherty, provided wonderful guidance and expertise.

Thank you to the individuals who searched their attics and basements to provide important photographs. Those listed with an asterisk are JGSLI members: William Bernstein* (WB), Dorothy Chanin* (DC), Sharon Fahrer (SF), Virginia Fortune Ogilvy (VFO), Tess Pierce Garber (TPG), Lester Goldschmidt* (LG), Sharon Goldwyn (SG), Fern Gutman* (FG), Jack Hayne* (JH), Hans Henke (HH), Morris Hodkin (MH), Alice Kasten* (AK), Amy Gold Kaufman (AGK), Joy Kestenbaum (JK), Benjamin Israel (BI), Laura Kramer (LK), Robert Leshansky (RL), John Paul Lowens* (JPL), George Mann (GM), Rhoda Miller* (RM), Susan Privler (SP), Louis Silfin* (LS), Robert Seperson (RS), Victor Mark Susman* (VMS), and Devorah Wang* (DW).

The advice and guidance of the archivists, historical societies, and organizations provided invaluable support toward the furtherance of this project. The repositories are as follows:

92nd Street Y (92Y)
Ancestry.com
Bay Shore Historical Society (BSHS)
Babylon Town Historian (BTH)
B'nai Israel Reform Temple (BIRT)
Cold Spring Harbor Library and Archives (CSHLA)
Cradle of Aviation Museum (CAM)
Farmingdale Public Library and Farmingdale/Bethpage Historical Society (FPL/FBHS)
Farmingdale State College (FSC)
Greenlawn-Centerport Historical Association (GCHA)
Hillel Foundation for Jewish Life at Stony Brook University (HF)
Hofstra University Archives (HUA)
Hofstra University Special Collections/Long Island Studies Institute (HUSPCOL/LISI)
Kings Park Heritage Museum (KPHM)
Kings Park Jewish Center (KPJC)
Levittown Public Library History Collection (LPLHC)
Library of Congress, Prints & Photographs Division (LOCPPD)
Lindenhurst Historical Society (LHS)
Lloyd R. Sherman, permission of his children (LRS)

Long Beach Historical and Preservation Society (LBHPS)
Longwood Public Library, Thomas R. Bayles Local History Room (LPL)
Nassau County Department of Parks, Recreation, Museums, Photo Archives Center (NC)
New York State Office of Mental Health (NYSOMH)
Northport–East Northport Public Library (NPL)
Oheka Castle Hotel and Estate (OC)
Oyster Bay Historical Society (OBHS)
Plainview–Old Bethpage Public Library Photographic Collection (POBPC)
Sinai Reform Temple (SRT)
Southold Historical Society (SHS)
Straus Historical Society
Temple Adas Israel (TAI)
Temple Beth El of Patchogue (TBP)
The Arthur Szyk Society
Three Village Historical Society (TVHS)
Touro Law Center (TLC)
University Archives, Stony Brook University Libraries (UASBUL)
Village of Babylon Historical and Preservation Society (VBHPS)

INTRODUCTION

Long Island is the eastern region of the New York City metropolitan area. Queens County was part of modern Nassau County until 1899 but remained socially connected for years afterward. For the purpose of this book, Long Island encompasses the current Nassau and Suffolk Counties.

During the Colonial era, there were a few isolated Jews who ventured to East Hampton, namely Aaron Isaacs and Joseph Jacobs. While there are excellent references to Isaac's Jewish identity, he is also known to have converted to the dominant Presbyterianism of that time and place. Isaac Hart, a Tory sympathizer from Newport, escaped to the British holding at Fort St. George in Mastic, only to be brutally murdered. Joseph Montefiore, a lawyer related to Sir Moses Montefiore, lived in Sag Harbor during the 1820s. There is debate as to whether he is buried there. Apart from such instances, there is little evidence of a Jewish presence during this early period.

In the latter part of the 19th century, Jewish peddlers from New York City began making their way eastward to sell their wares. Small communities began to grow because of employment opportunities such as the watchcase factory in Sag Harbor, the rubber factory in Setauket, and the button factory in Breslau (now Lindenhurst). In the histories of early congregations, a common theme is "It started with a *minyan* . . ." Small groups of Jews would gradually begin to organize and formalize into a Jewish community, defined as having a congregation and a cemetery. As congregations grew in size, worship and meetings moved from a home to the eventual building of a synagogue. One such example is the Jewish Brotherhood of Kings Park, incorporated in 1906, which met in the home of Gershon Patiky. In 1908, the congregation moved into a neighboring building on what is today Patiky Street. The strong seeds of a Jewish presence on Long Island were established by the late 19th and early 20th centuries.

Between World War I and World War II, existing communities emerged and Jewish-owned businesses flourished despite the anti-Semitic presence of the Ku Klux Klan and the Nazi-inspired Camp Siegfried. After World War II, there was a significant increase of Jews on Long Island. Jewish real estate developer Abraham Levitt and his son William Levitt brought the suburban model of housing development to Long Island with the building of Levittown. With real estate developers like Gilbert Tilles and Leon Miller, Long Island became a booming suburb of New York City and home to a large Jewish population. In the 1950s and 1960s, there was considerable flight from the traditionally Jewish neighborhoods of New York City to the suburb of Long Island. This increase in the Jewish population enabled the expansion and growth of synagogues and Jewish organizations, which abounded in communities such as Bay Shore, Great Neck, Dix Hills, Cedarhurst, and Plainview. This growth has been referred to as the "golden age" of synagogue membership. Despite this growth, there was still social discrimination during this period. Jews were not granted membership in some country clubs and organizations. The building of Long Island Jewish Hospital in New Hyde Park is an example of the effort to combat discrimination, as Jewish doctors were not provided privileges at other existing hospitals.

After this period of growth and development, the late 20th and early 21st centuries saw Long Island Jewish communities reflect the nationwide trend of assimilation and decline in synagogue membership. With increased interfaith families and religious non-affiliation, many synagogues merged. Examples of consolidation are Sinai Reform Temple in Bay Shore merging with B'nai Israel Reform Temple in Oakdale and the Lindenhurst Hebrew Congregation merging with Congregation Beth-El of Massapequa. Jewish culture, however, thrives in entertainment, an abundance of bagel shops, and strong membership in the five Y-JCC organizations on Long Island. There are several modern Orthodox communities, particularly in the Five Towns (Lawrence, Cedarhurst, Woodmere, Inwood, and "The Hewletts") and Long Beach, which are holding fast to traditional religious practices. A growing Chabad movement throughout Long Island provides considerable outreach. Great Neck is a stronghold of the relatively new Iranian/Persian Jewish community. There continues to be an ebb and flow of Jewish life on Long Island that provides a rich religious and cultural experience.

Long Island has been home to many Jewish people prominent in the arts and other endeavors. With Great Neck's proximity to New York City, entertainers such as Groucho Marx and Sid Caesar made their homes there. Great Neck is the home of Sarah Hughes, who won the 2002 ice-skating Olympic gold medal. The eastern end of Long Island, commonly known as "the Hamptons" was the permanent and summer residence of the artistic community, including luminaries such as artist Lee Krasner. Examples of other Long Islanders of note are singer Billy Joel, who grew up in Levittown and makes his home in Oyster Bay; author Alice Hoffman, who resides in Huntington; Judy Jacobs, a longtime Nassau County legislator representing northeastern Nassau County; and Congressmen Steve Israel and Lee Zeldin, native Long Islanders who currently represent the region at a national level. This list is meant to be only representative of the region's luminaries in a variety of endeavors.

Long Island is home to many Holocaust survivors. In acknowledgment of their devastating chapter in history, there are several regional sites that support recognition of the Holocaust and promote tolerance in modern society. These sites are the Holocaust Memorial and Tolerance Center of Nassau County in Glen Cove; the Suffolk Center on the Holocaust, Diversity and Human Understanding located on the Selden Campus of Suffolk County Community College; Holocaust Resource Center of Temple Judea in Manhasset; and the Anne Frank Memorial Garden in Arboretum Park in Melville. Approximately 90 synagogues on Long Island own rescued Holocaust Torahs.

While there are some publications about the Jewish history on Long Island, as represented in the bibliography, there is a dearth of recent publications. The format of this book does not allow a comprehensive history; this publication is unique for its little-known information that will hopefully add to the breadth of knowledge of the history of the Jewish community of Long Island.

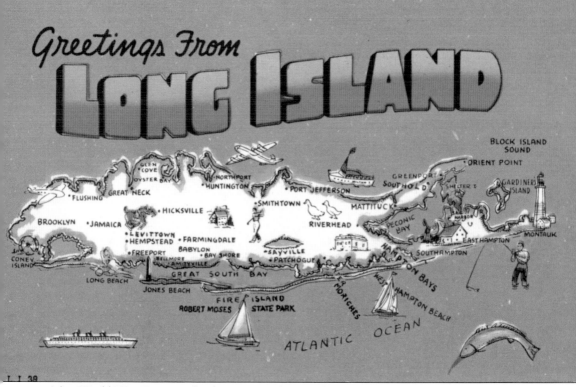

After World War II, Long Island experienced vast suburban expansion as well as growth in its popularity as a summer resort. This postcard image of a Long Island map boasts many locations found throughout this book. The map also provides the reader with a snapshot view of the bicoastal shoreline and the recreational activities available on Long Island. (BTH.)

One

BUILDING A JEWISH COMMUNITY

"It started with a minyan . . ." A minyan is the Jewish traditional quorum of 10 men needed for group prayer participation. Although Jews have been known to live on Long Island since the Colonial era, it was not until the mid-19th century that Jewish communities began to develop. The history of synagogues in the early Jewish communities on Long Island often opens with the concept of beginning with a minyan. Peddlers from New York City would work their way across Long Island and either spend Sabbath with local Jewish families or return to the city by sundown on Friday evenings. These peddlers witnessed a rural way of life drastically different from the tenements of the Lower East Side and Brooklyn and closer in style to the *shtetls* (small market towns) they left behind in the old country.

In Sag Harbor, a watchcase factory hiring Jewish workers brought a large influx of congregants to Temple Adas Israel, now Long Island's oldest synagogue. In Glen Cove, a minyan developed into Congregation Tifereth Israel, now the longest continuing congregation on Long Island. In Setauket, a rubber factory brought Jewish employment following the firing of Irish workers who wanted to unionize. Initially attracted by factory employment, Jewish merchant businesses, such as dry goods stores and butchers, flourished in these communities as the factories went out of business. Early congregations also developed in Lindenhurst, Bay Shore, Kings Park, Patchogue, and Greenport, among other locations.

Jewish communities frequently began with a minyan meeting in someone's home. From there, land was acquired for a cemetery, a synagogue building was constructed, and a *mikvah* (ritual bath for women) was built. Initially, kosher food was brought to Long Island by peddlers or by local residents who traveled to New York City to purchase such provisions. As rabbis and ritual slaughterers of kosher meat came to the burgeoning Jewish communities, congregations grew and flourished.

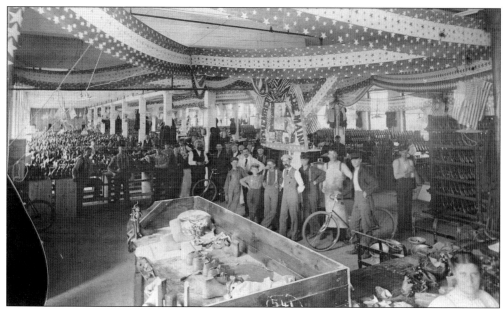

The rubber factory in Setauket provided employment to the increasing number of Jews who settled in this area of Suffolk County. In this 1898 interior photograph of the factory, employees react to the tragic sinking of the USS *Maine* with a patriotic gathering. The *Maine* was blown up in Havana Harbor, precipitating the Spanish-American War. (TVHS.)

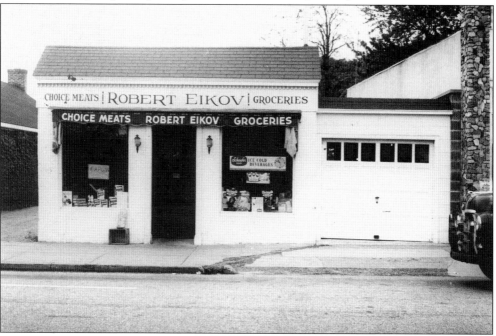

Samuel Eikov and Dora Pinnes, Polish and Russian Jewish immigrants, met in Setauket and married. They raised eight children in Setauket and were prominent members of the local Jewish community. Samuel and Dora worked in the local rubber factory until it closed. Their son Robert Eikov, born in 1907, and his older brother Sam owned a butcher shop on Main Street in Setauket. When Robert married, he opened his own market. (TVHS.)

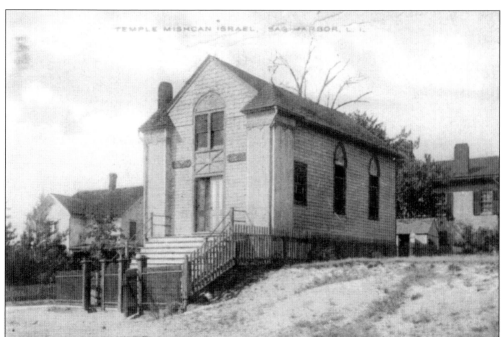

When a watchcase factory replaced the declining whaling industry of Sag Harbor, the owner sought to employ Russian, Polish, and Hungarian immigrants as inexpensive labor. By 1883, the Jewish Association of United Brethren and the Independent Jewish Association were founded. In 1891, two cemeteries were dedicated as planning began for a synagogue first named Temple Mishcan. The synagogue building, now Temple Adas Israel, continues today. The original mikvah exists in the building. (TAI.)

By 1900, there were conflicts in culture and style of worship between Russian and Polish Jews with Hungarian Jews. The Hungarian Jews joined with a small Jewish population in Greenport to create a congregation of their own. In 1904, a synagogue was dedicated. Congregation Tifereth Israel continues today with a small display in the lobby of original mikvah artifacts. (SHS.)

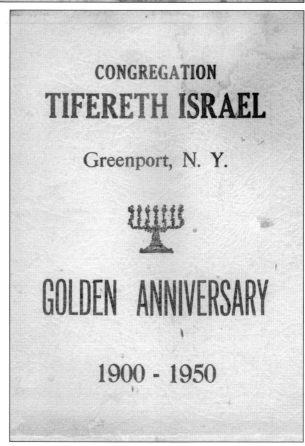

CONGREGATION
TIFERETH ISRAEL

Greenport, N. Y.

GOLDEN ANNIVERSARY

1900 - 1950

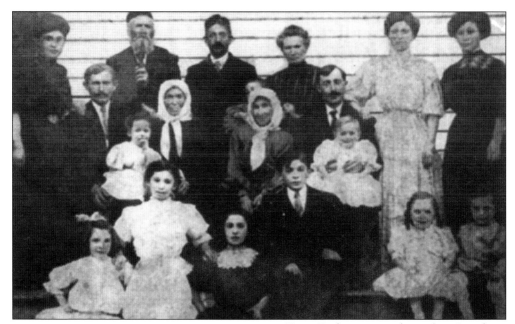

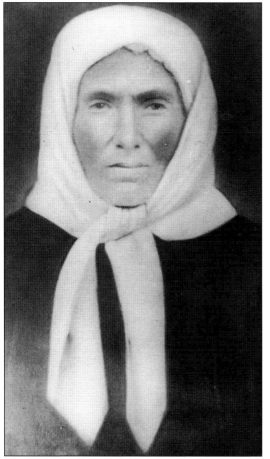

Kings Park is among the earliest Jewish communities on Long Island. Gershon and Rachel Leah Patiky were the progenitors of the family who started as farmers in 1897 and eventually owned successful businesses in the area. Gershon Patiky's vision led to the community's first congregation, the Jewish Brotherhood of Kings Park, in 1906. Services were held in the Patiky home. (KPHM.)

Rachel Leah bat Moshe haKohen, as described on her gravestone in the cemetery of the Kings Park Jewish Center, lived from 1840 to 1923. Wife of Gershon, they are listed as Rose and George in the 1910 census and living with their son Elias and his family. Born with the surname Knobel, she married Gershon Patiky in Russia and arrived in the United States in 1892. The couple had six children. (KPHM.)

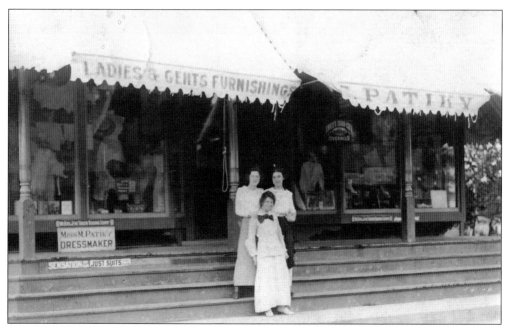

One of the successful Patiky businesses was the dry goods store shown here. In 1905, the Kings Park State Hospital opened. It was a large institution designed to provide services to the mentally ill population primarily from Brooklyn and Queens. The Patiky dry goods store received the contract to make the hospital uniforms, and this arrangement greatly added to the success of the business in the community. (KPHM.)

Sam Patiky, son of Rachel and Gershon Patiky, had the job of traveling into New York City to buy kosher food for the burgeoning Jewish population in the area. The Patiky family married into the Okst family, another important early family of the Kings Park Jewish community. (KPHM.)

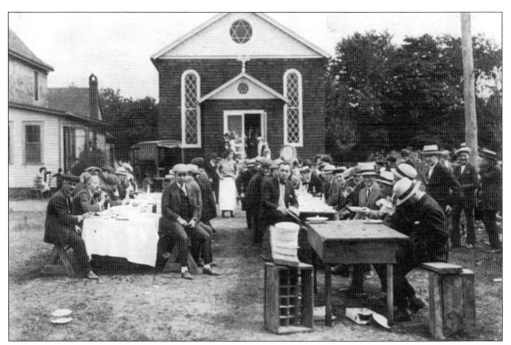

Founded in 1906, the original building of the Kings Park Jewish Center was located on Patiky Street. On Rosh Hashanah in 1923, the synagogue hosted a dinner for veterans, as seen here. This building was destroyed by a fire in 1962, and a new one was erected on East Main Street. (KPHM.)

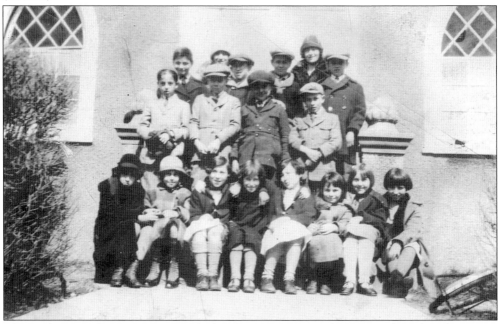

The Patchogue Hebrew Congregational Church was incorporated in 1904 and purchased cemetery property in 1911. A sign of the thriving Jewish community is this 1924 photograph of students from the religious school in front of the original building. In 1928, the name changed to the Patchogue Hebrew Congregation under the presidency of Mayer Tellman. (TBP.)

In 1924, a large family wedding took place at the Jewish Congregation Neta Tzarchea in Lindenhurst, originally known as Breslau from 1870 to 1890. Pictured are an unidentified bride, groom, and family standing in front of the original synagogue on Fourth Street. Based on the clothing and number of guests, this wedding was a major event. (BTH.)

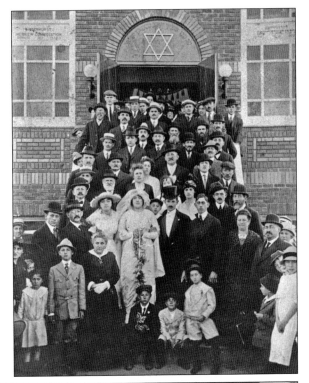

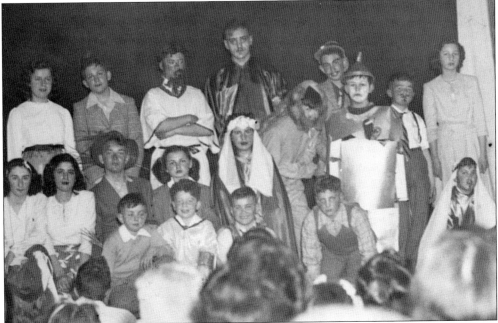

The emerging Jewish community of Breslau purchased property within the Breslau Cemetery in 1876, formally establishing the Jewish community. The congregation, Neta Tzarschea, was formed in 1874 and met in homes until a building was constructed in 1913. This photograph shows costumed children during a Purim celebration at the synagogue, which became the Lindenhurst Hebrew Congregation. In 2002, the congregation merged with Temple Beth El of Massapequa. (LHS.)

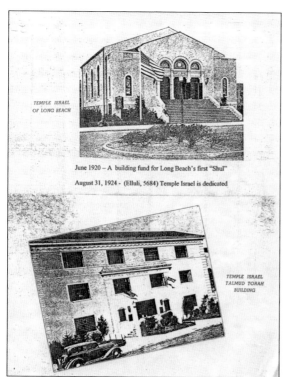

TEMPLE ISRAEL
OF LONG BEACH

June 1920 – A building fund for Long Beach's first "Shul"

August 31, 1924 - (Elluli, 5684) Temple Israel is dedicated

TEMPLE ISRAEL
TALMUD TORAH
BUILDING

Temple Israel of Long Beach was founded in 1920 and by 1924 had raised enough funds to construct a synagogue, with Morris M. Goldberg serving as the first rabbi. In 1930, a Talmud Torah school building was added. In 1966, a third building, the Rose and Irving H. Engel Center, was dedicated in response to the need to provide additional services to the growing Jewish community. (LBHPS.)

As the congregation of Temple Israel flourished into the 1960s, the Men's Club, Sisterhood, and other Temple social groups increased its community service activity. These active congregants are celebrating at an event that likely occurred in the Rose and Irving H. Engel Center. (Photograph by Platnick, LBHPS.)

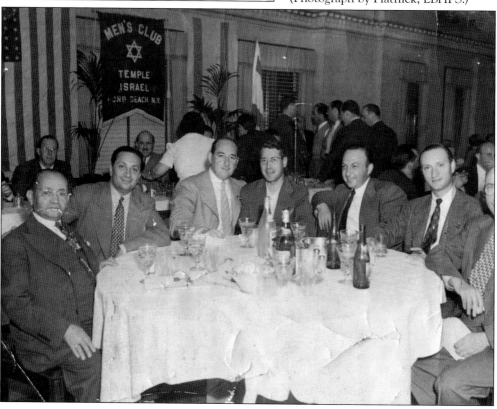

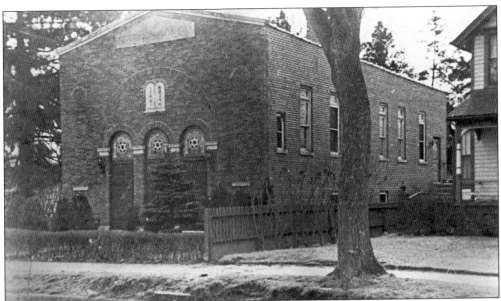

In the 19th and early 20th century, there was no synagogue in Babylon. Jews living there walked alongside the Long Island Rail Road tracks to Lindenhurst, the next village to the west, in order to worship with the nearby congregation. It was not until 1936 that these Jews were a large enough group to purchase property and build a synagogue on George Street. Congregation Beth Shalom is now a Conservative synagogue located on Deer Park Avenue. (VBHPS.)

Solomon Siegel was born in 1895 in Babylon. The son of Charles Siegel and Rachel Felcher Siegel, a founding Jewish family of Babylon, he became the head of household after his father's passing in 1916. The 1920 census describes him working as a clerk for the Long Island Rail Road. He resided with his mother and five younger siblings. (VBHPS.)

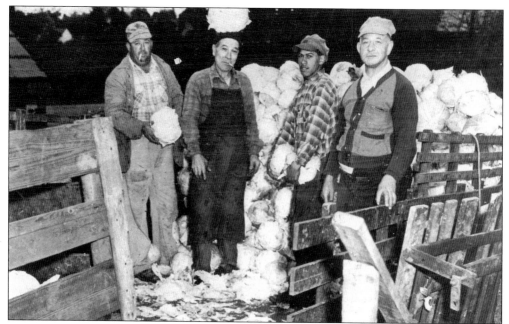

Long Island had an important pickle industry in the early decades of the 20th century. Abraham Golden emigrated from Russia in 1886 and soon founded Golden Pickle Works in Manhattan. His two eldest sons, Harry and Hyman, above right, joined the business, which expanded to facilities in Deer Park, Greenlawn, and Calverton. The 1943 Harry Rocker watercolor painting below depicts the factory building in Greenlawn with the distinctive pickle sign bearing the Golden name. After surviving the 1918–1920 cucumber blight, the business suffered two unfortunate disasters. In 1926, a Long Island Rail Road train derailed at the rail split to the Calverton factory and crashed into the building. In 1935, the Deer Park plant was engulfed in a forest fire that overtook the area. Despite these disasters, Golden Pickle Works remained in business on Long Island into the 1950s. (Both, GCHA.)

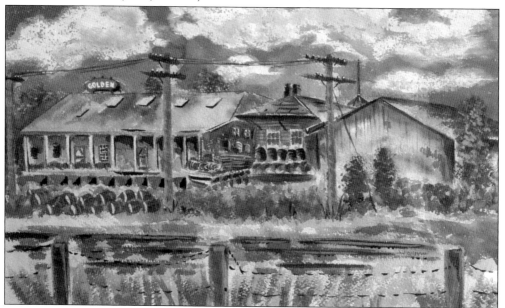

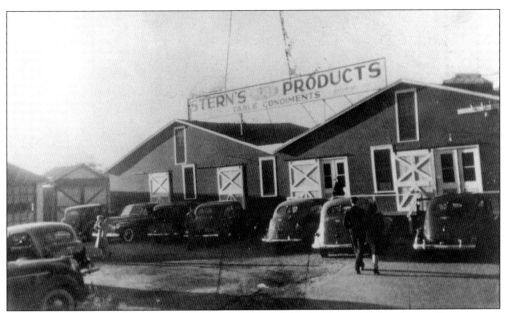

Stern's Pickle Products, located in Farmingdale and founded in 1899 by Aaron Stern, was a successful business that capitalized on the Long Island cucumber crop. After the cucumber blight, production moved to related condiments, particularly sauerkraut, due to the availability of a large local cabbage crop. The Stern's truck pictured below is parked on Main Street in Farmingdale. Eddie's Delicatessen is now the location of Stuff-A-Bagel. Aaron Stern was also a founding elected secretary of the First Hebrew Congregation of Farmingdale in 1926, known since 1944 as the Farmingdale Jewish Center. Descendants of Aaron Stern have remained active in the community and in the Farmingdale Jewish Center. (Both, FPL/FBHS.)

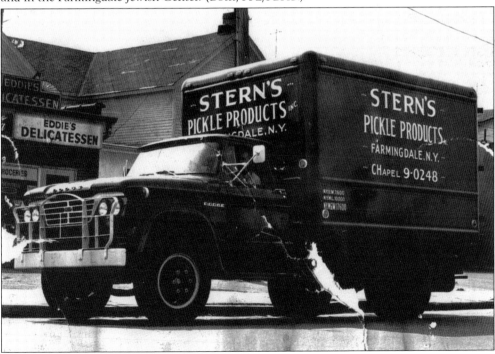

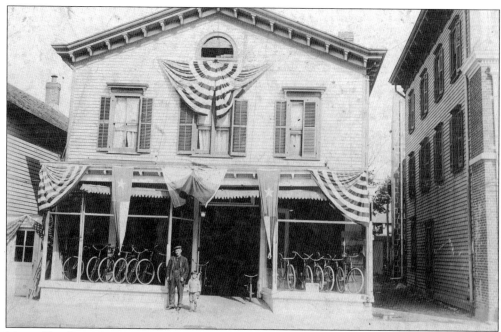

Morris Freedman, born in Poland, established his Bay Shore bicycle shop in 1906 in a different location from the 1917 photograph above. The 1920 federal census indicates that Freedman was also a motorcycle dealer. The business moved and expanded to include much additional merchandise as well as the curbside gasoline or kerosene pump shown below. Adjacent to the Morris Freedman business in 1933 was the jewelry store of Samuel Spivak, another Jewish Bay Shore proprietor. The distinctive Spivak clock was moved whenever the business relocated within the town. The Freedman and Spivak families both lived in Bay Shore. (Both, BSHS.)

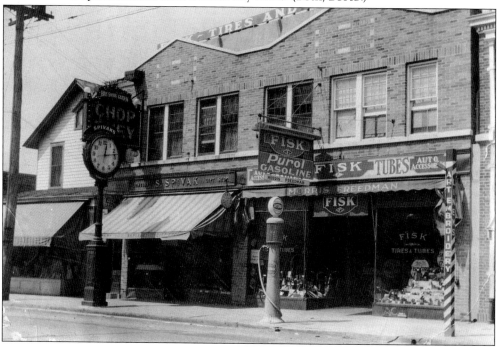

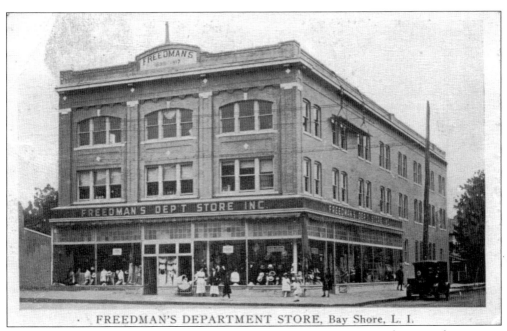

FREEDMAN'S DEPARTMENT STORE, Bay Shore, L. I.

A relative of Morris Freedman owned Freedman's Department Store, a longtime business in Bay Shore. In 1917, a fire destroyed the building. Over the years, the store underwent several renovations, all in the same location. This photograph shows the remodeled store. Note the pride in the successful enterprise, as the newest building boasted a frieze with the dates of the original building: 1898–1917. The building no longer exists. (BSHS.)

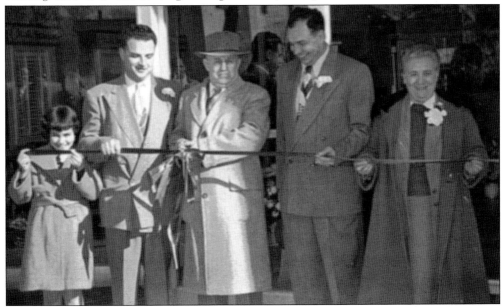

Cantor Bros. was a highly successful and reputable Bay Shore Jewish-owned business that expanded multiple times over decades to include glass, flooring, and window treatments. Pictured at a late 1940s ribbon cutting ceremony are, from left to right, Janice Cantor Rosenberg, Irving Cantor, an unidentified official, Harry Cantor, and Jenny Cantor. After Sam Cantor passed away in 1944, his wife, Jennie, known as "Mamma" to customers, continued the business with their son Irving. (SF.)

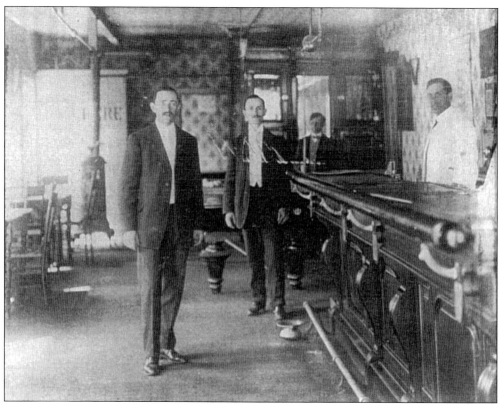

Majer (left) and David Greenfield (second from left) were brothers and proprietors of the Greenfield Hotel in Patchogue. They are pictured here in 1910, when they purchased the hotel. During Prohibition, cider was sold at the hotel. On Majer's World War I draft registration, he lists the hotel address as 172 West Main Street, Patchogue. (HH.)

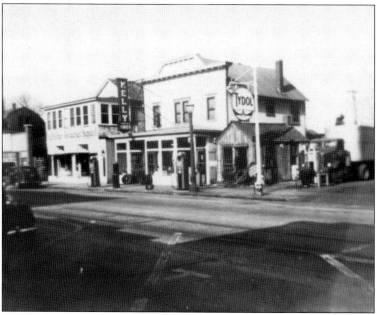

This c. 1950 photograph of Arthur Simon's service station on the north side of West Main Street in Patchogue shows his street-side gas pumps. After being in this business for over six decades, Simon strongly resisted the Village of Patchogue's effort to purchase his property for the community development of a commercial project. (HH.)

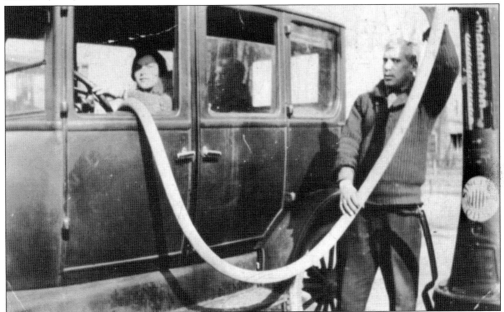

DONALD BLAKESLEE, INC., 89 EAST MAIN ST., PATCHOGUE, N. Y.
TELEPHONE PATCHOGUE 2500

SERVICE TICKET

N.º 8305

M. Simon
CUSTOMER
Main St
STREET
Sag Harbor
CITY

DATE 1-17-36

JOB NO.

CUSTOMER'S COPY

	GUARANTEE EXPIRATION DATE	CONTRACT	INSPECTION	NO CHARGE	CHARGE
Timken Silent Automatic Oil Burners Oil Furnaces	LABOR				3 00
Heating Equipment Lee Automatic Hot Water Heat American Radiator Co. Heating Boilers	MATERIAL (LIST EACH ITEM SEPARATELY)				
Radios Stromberg-Carlson R.C.A. Victor Atwater-Kent Philco	_1 - Model C motor unit overhaul_				10 00
Electric Refrigerators Westinghouse					
Washing Machines Westinghouse Hot Point A B C					
Lamps GE Mazda R.C.A. Cunningham Tubes	_Southampton 967_		TOTAL	$13 00	
Electrical Appliances Westinghouse General Electric Manning-Bowman Toastmaster Mixmaster Hamilton Beach	☞ R E M A R K S A N D C O M M E N T S O N R E V E R S E S I D E			.50	
			CUSTOMER'S ACCEPTANCE		$12.50
	Surknaff SERVICE MAN		_M. Simon_ SIGNATURE		

When the Patchogue Hebrew Cemetery was incorporated in 1911, Meyer Simon was a signee. In the 1920 census, Simon is listed as a junk dealer. At the time of the 1925 New York State census, he was employed in the used-car business. This car service ticket indicates that Simon owned a Model C Ford in 1936. By the 1940 census, Simon is listed as the proprietor of a service station. (HH.)

Joseph and Lena Schwartzberg moved from the Bronx to East Islip around 1930. Joseph was a religious slaughterer and at first owned a poultry wholesale business. Years later, he owned a gas station and opened the first laundromat in East Islip. Elizabeth Schwartzberg, their daughter, married Louis Hodkin of Patchogue. (MH.)

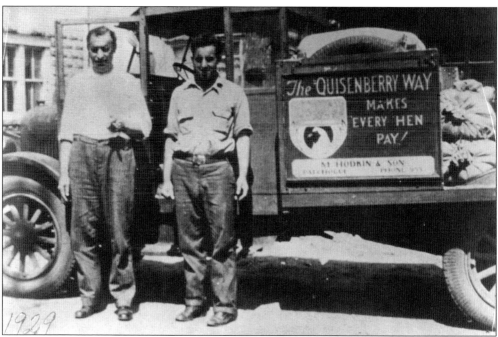

Morris (above, at left) and Ada Hodkin settled in Patchogue around 1920. At first, Hodkin was a peddler. A short time later, he opened his business, M. Hodkin and Son, with his son Lawrence, selling chicken feed and, in later years, home fuel oil. Several years later, another son, Louis (above, at right), joined the business and the name changed to M. Hodkin and Sons. Hodkin was highly respected and was known throughout the area. He was founder and president of the Patchogue Jewish Center and founder of the Patchogue Hebrew Cemetery. Morris and Ada were blessed with eight children: Samuel, Minnie, Anna, Lawrence, Dora, Louis, Gretchen, and William. Members of the Hodkin family still reside in Patchogue. (Both, MH.)

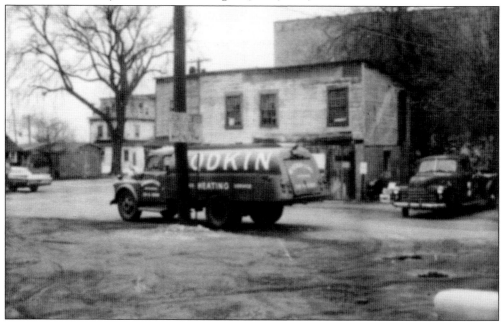

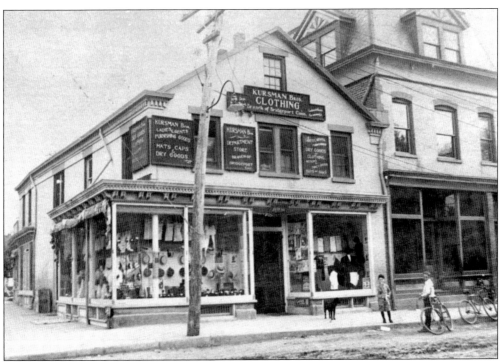

After a 1907 fire that had minor impact on the then historic Ludlam Building in Oyster Bay, it was sold to Philip Kursman, who moved his clothing business to this larger location. David Bernstein, who had served with Kursman in World War I, joined the business as a partner. When the business burned in 1932, Bernstein reconstructed the building and operated Dave's Shop, a haberdashery, into the 1960s. The 1940 census describes David Bernstein as owning his own shoe store. By the time of the photograph below from the 1960s, the business had grown into a department store. David Bernstein and his son Jacob held leadership positions in the Oyster Bay Jewish Center. In 1963, when the congregation was formed, it was Bernstein who arranged for religious services to be held at the Oyster Bay Community Center. (OBHS.)

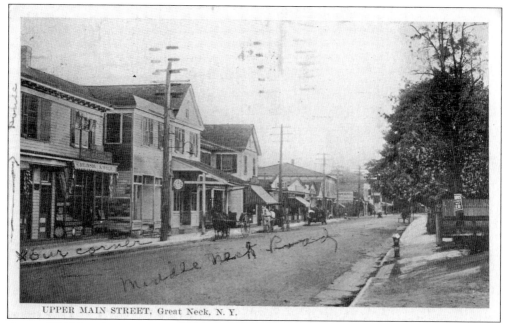

UPPER MAIN STREET, Great Neck, N. Y.

Avrum Wolf, Jewish immigrant tailor to William R. Grace, mayor of New York City, was brought to Great Neck at the behest of his patron. Around the turn of the 20th century, as the first Jew to live in Great Neck, Wolf opened a tailor shop, later engaging in the real estate and insurance business. This venture can be seen in this Main Street photograph. Wolf was also a founder of Temple Beth El, established in 1928. (AK.)

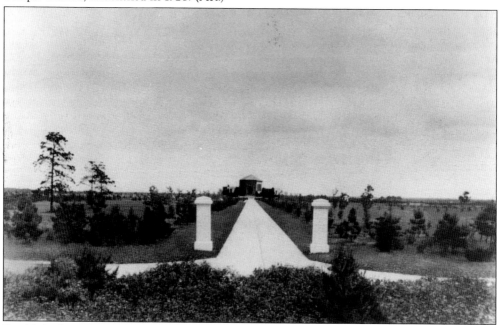

Established in 1928, New Montefiore Cemetery in Farmingdale was needed when its parent cemetery in Springfield, Queens, became overcrowded. During this time, the Town of Babylon provided considerable land to several cemeteries, three others of which are Jewish burial grounds: Wellwood, Beth Moses, and Mount Ararat. (TOBHO.)

Two

EXPANDING THE JEWISH RELIGIOUS COMMUNITY

With the end of World War II, an era of important changes on Long Island developed due to a combination of sociological and economic factors. The GI Bill enabled veterans to purchase homes with barely a down payment. The return of these soldiers also marked the beginning of the baby boom generation, as these young soldiers were ready for marriage and the beginning of a life-affirming family. William Levitt, who created the first planned suburban community, built Levittown in the heart of Nassau County. Other developers supported regional growth, such as Gilbert Tilles, who built shopping strip malls; and Leon Miller, who built numerous homes in many communities. Robert Moses had already created Jones Beach and other recreation areas as well as the parkways providing easy access to and from New York City. A substantial percentage of the young families were Jewish, and so began the exodus leading to the expansion of the existing religious community.

During the decades from roughly 1950 to 1980, there were demographic changes in New York City neighborhoods that had been traditionally Jewish, such as Tremont, Williamsburg, East New York, and Flatbush. The 1960s are noted as an era of "white flight" from the city, and Long Island communities were a significant recipient of Jews. During these decades, early synagogues were bursting with the need for more space. The response was either to expand or build new buildings such as what occurred in Lindenhurst and Great Neck. In other newer communities, congregations were organized such as in Oakdale, Plainview, and Bay Shore.

Resulting from this growth of the Jewish population, congregations formed Sunday schools and Hebrew classes in order to prepare the children of these young families for bar mitzvah and confirmation. In the 1950s and 1960s, most girls only experienced confirmation. In later decades, there came the growing popularity of bat mitzvah to be followed by adult b'nai mitzvot for those who had never achieved that religious coming of age. A new era had clearly commenced for the Jewish community of Long Island.

In 1963, a group of Jewish families began meeting in the American Legion Hall in East Islip. The group formed the core of B'nai Israel Reform Temple, incorporated in 1964. By 1968, the congregation was able to purchase property in Oakdale for a permanent building. A sign of intent was placed on the property, and construction began. The new temple was dedicated in 1970 in time for the High Holidays. The building was located on the corner of Idle Hour Boulevard and Biltmore Avenue. In 1984, with a growing congregation, B'nai Israel built a larger building on property donated by Morton Pickman. The new temple building, on Oakdale Bohemia Road, was dedicated in June 1984. The original building is now the Anthony Giordano Gallery of Dowling College. (Both, BIRT.)

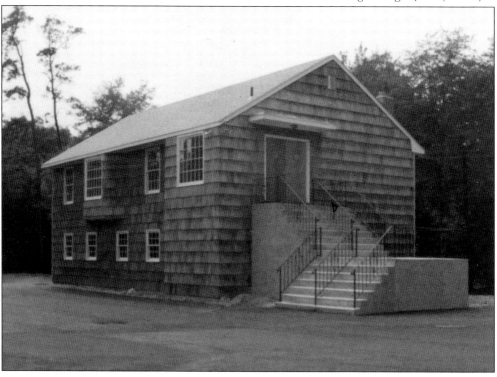

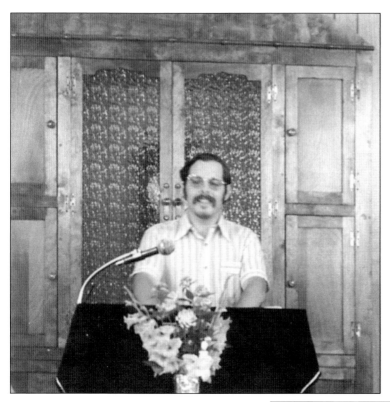

In 1972, student rabbi Steven Moss administered to the religious needs of B'nai Israel Reform Temple. Upon ordination, Rabbi Moss took the position of full-time rabbi and still continues in that role due to the impressive energy of the congregation. He is a community leader and holds positions in local nonprofit and public organizations promoting tolerance, diversity, and ethical behavior. (BIRT.)

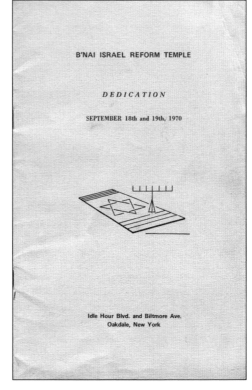

A dedication booklet was published in 1970 to commemorate the early accomplishments of the congregation. As the congregation grew, it was very grateful for the good-neighbor policy of Dowling College, which provided space for the religious school and High Holy Day services. In 2014, a journal was published in celebration of 50 years of serving Oakdale and the surrounding areas. (BIRT.)

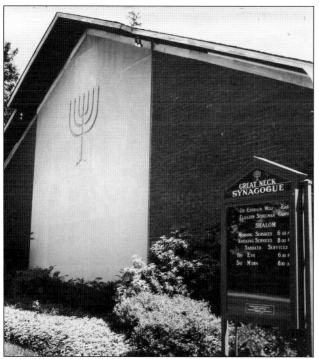

Temple Beth-El of Great Neck was founded in 1928. With the influx of Jews to Great Neck, there arose the need for more synagogues. In the 1940s, Temple Israel and Temple Emanauel of Great Neck were established. In 1951, author and Great Neck resident Herman Wouk formed a group to establish the orthodox Great Neck Synagogue. George Weinstein was the first president, and Rabbi Dr. Moshe Tendler became the first rabbi, later followed by Rabbi Dr. Ephraim Wolf. By 1954, the Great Neck Synagogue building, pictured here, was dedicated. A Hebrew day school, the North Shore Hebrew Academy, was also established. (Both, SG.)

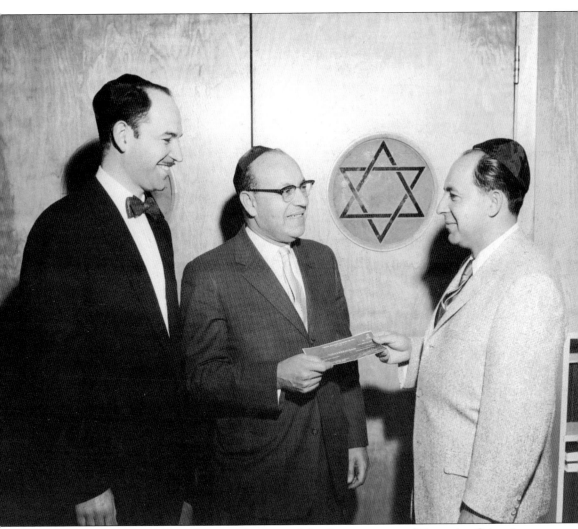

In 1953, Solomon S. Goldwyn became chairman of the Construction and Campaign Committee of the Great Neck Synagogue. He had a vision to build an Orthodox community with a Hebrew day school and a mikvah. From left to right, Rabbi Dr. Ephraim Wolf and Goldwyn are pictured receiving a donation from Samuel H. Wang. These men helped bring the vision of this synagogue to fruition. (DW.)

"בשנת היובל הזאת תשבו איש אל אחזתו"

"In this year of jubilee, each of you shall return to his holding."

Leviticus 10:13

Tess & Morris Garber

For 50 Years of Unfailing Devotion

Midway Jewish Center

1958 – 2008

Rabbi

President

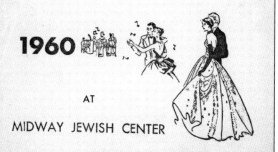

Souvenir Photograph

New Years Eve

1960

AT

MIDWAY JEWISH CENTER

In 1958, Tess and Morris Garber purchased a home in Jericho, fulfilling their desire to live in a Jewish community. They became active members of the Midway Jewish Center in Jericho in all aspects of synagogue life. Their son Gary became a bar mitzvah at this synagogue. The Garbers attended nearly every New Year's Eve celebration, as well as countless other events. Tess was feted by the synagogue with a "This is your Life" celebration. In 2008, the Garbers were honored for their 50 years of service to the synagogue. (Both, TPG.)

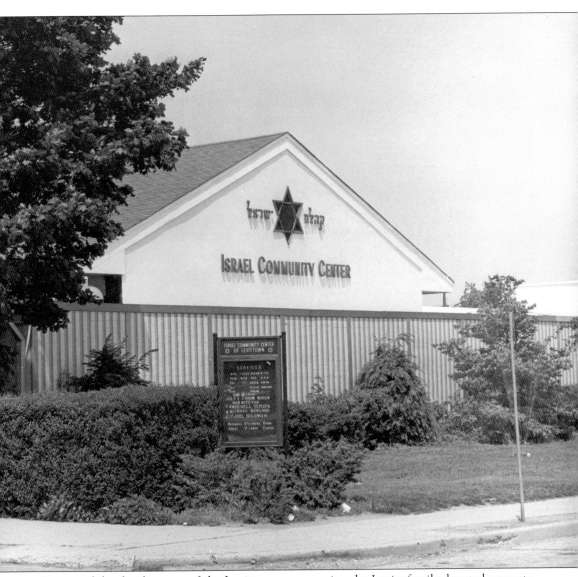

As part of the development of the Levittown community, the Levitt family donated property within the community for the purpose of building a synagogue. The Israel Community Center congregation was established in 1948. The building was erected shortly thereafter, and the congregation continued until 2011, when it merged with the Farmingdale Wantagh Jewish Center. (LPLHC.)

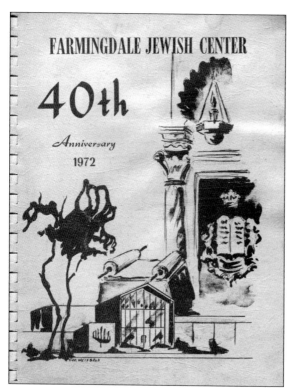

George Mann, a member of the Farmingdale Jewish Center, was on the Journal Committee for over 30 years. Mann had many connections who brought a considerable number of advertisements to the journals over the years. Mann is especially proud of the 40th anniversary journal from 1972. The cover features a sketch of the synagogue building. (GM.)

The Long Beach Jewish population flourished in the mid-20th century, leading to the rise of new congregations. Temple Emanu-El of Long Beach was established in 1945, the first Reform congregation in Long Beach. Bernard Kligfeld was rabbi at the time of the 15th anniversary celebration in 1960 and continued until 1982. The honoree, Jack Kromberg, was the first president and later a trustee of the synagogue. (LBHPS.)

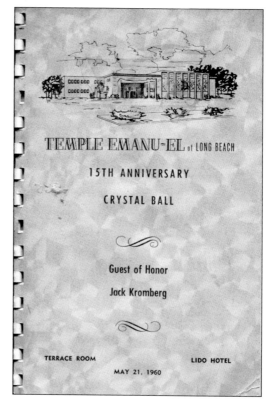

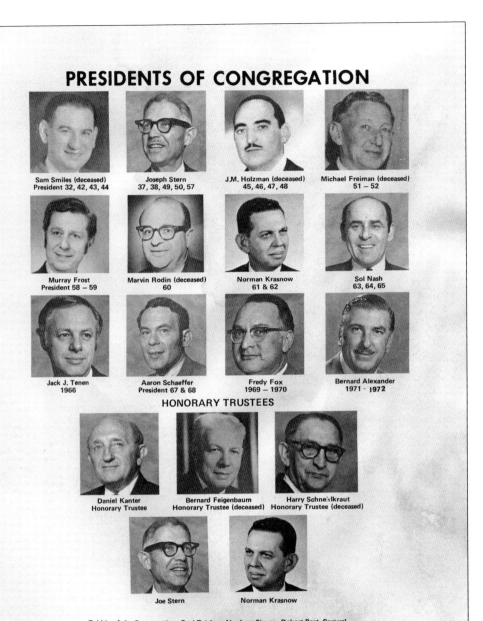

PRESIDENTS OF CONGREGATION

Sam Smiles (deceased)
President 32, 42, 43, 44

Joseph Stern
37, 38, 49, 50, 57

J.M. Holzman (deceased)
45, 46, 47, 48

Michael Freiman (deceased)
51 – 52

Murray Frost
President 58 – 59

Marvin Rodin (deceased)
60

Norman Krasnow
61 & 62

Sol Nash
63, 64, 65

Jack J. Tenen
1966

Aaron Schaeffer
President 67 & 68

Fredy Fox
1969 – 1970

Bernard Alexander
1971 - 1972

HONORARY TRUSTEES

Daniel Kanter
Honorary Trustee

Bernard Feigenbaum
Honorary Trustee (deceased)

Harry Schneidkraut
Honorary Trustee (deceased)

Joe Stern

Norman Krasnow

Rabbis of the Congregation: Paul Teicher, Abraham Simon, Robert Port, Samuel Epstein, Nathan Wasler. Other Rabbis such as Rabbi Morris Pickholtz served the Congregation at various times as on weekends and Holidays.

In 1927, the Farmingdale Hebrew Association was formed. Sam Smiles served as president in 1932. Joseph Stern was the presiding officer when the congregation was restructured as the Farmingdale Jewish Center. The presidential history of the congregation is shown as well as the honorary trustees and past rabbis in this 40th anniversary journal. In 2007, the 80-year-old synagogue merged with the Wantagh Jewish Center. (GM.)

The second synagogue of the Lindenhurst Hebrew Congregation was built near the corner of West Fourth and West John Streets. The congregation had by then joined the Conservative movement and was a vibrant part of the local Jewish community with a religious school. In 1996, a decision was made to add a second story to the building. (LHS.)

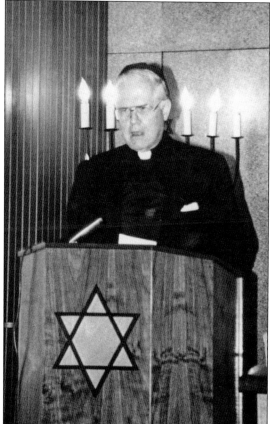

During the ground-breaking ceremony of the second-floor addition, there was a 1997 rededication of the synagogue. At that time, Deborah Lite was president, Marvin Demant was rabbi, and Sy Razler was the dedication committee chairman. Fr. Monsignor Hamilton of Our Lady of Perpetual Help is pictured here speaking at the May 19 dedication ceremony, demonstrating the ecumenical perspective of the Lindenhurst community. (LHS.)

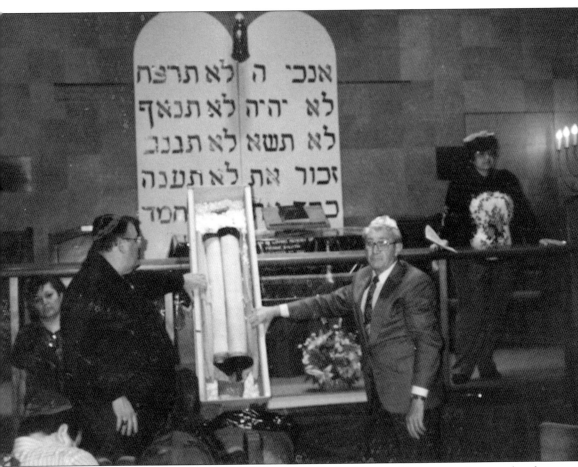

In the 1960s, a trove of Torahs collected and stored by the Nazis in Prague was discovered and subsequently adopted by synagogues worldwide to memorialize the Jewish community in the towns from which they might have originated. This photograph from the Lindenhurst Hebrew Congregation shows the Holocaust Torah dedication with co-presidents Milt Goldstein and Milton Shustak. (LHS.)

Sinai Reform Temple was formed in 1948 due to increased growth of the Jewish population in the wider Bay Shore community. With Morris Friedman as the first rabbi, the original purchased property contained a building that was formerly a school for handicapped children. Until the new synagogue building was dedicated in 1963, the original building was used as the synagogue. After the new building was dedicated, the original building was used for the religious school. Below is a page from the ground-breaking ceremony program. At that time, Morton M. Kanter was the rabbi who served the congregation from 1958 to 1964 (Both, SRT.)

GROUND BREAKING CEREMONIES PROGRAM
OUTDOORS

Presiding - Dr. Robert S. Levin

Invocation - Rabbi Joseph H. Lief
Chaplain, Northport Veterans Administration Hospital
Northport, New York

Greetings and Remarks - Dr. Robert S. Levin
Co-chairman Building Committee
Sinai Reform Temple

Breaking of Ground - Calman Lasky
President, Sinai Reform Temple

Mrs. Stephen T. Voit Andrew Haimes
President, Women's Club *President, Youth Group*
Robert Bebarfald Dr. Seymour Wasserman
President, Men's Club *Building Committee*

INDOORS

Presiding - Dr. Samuel T. Herstone

Welcome - Dr. Samuel T. Herstone
Co-chairman Building Committee

Greetings and Remarks - Calman Lasky
President, Sinai Reform Temple

Greetings - Thomas J. Harwood
Supervisor, Town of Islip

Greetings - Rev. Richard S. Parker
Minister Islip Methodist Church
Past-president Suffolk County Council of Churches

Greetings - Rabbi Daniel L. Davis
Director, New York Federation of Reform Synagogues

"He Watching over Israel" - Mendelssohn - Rosalie Wetzler Choirs

Remarks - Morton M. Kanter
Rabbi, Sinai Reform Temple

Address - Mr. Maurice Levin

Choir - "Ma Tovu"

Service of Consecration - Rabbi Kanter

Closing Hymn - "All the World" - Choir and Assemblage

Closing Prayer - Rabbi Israel Jacobs
Bay Shore Jewish Centre

A reception will immediately follow the program

The cover of the 1966 annual journal depicts the synagogue building, which featured a roof line that was designed to imitate the six-pointed Jewish star. In 1990, there was a disastrous fire that destroyed the building. The synagogue was rebuilt, but by 2014 the building and property had been sold and the congregation merged with B'nai Israel Reform Temple of Oakdale. (SRT.)

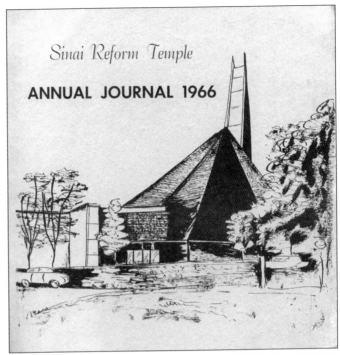

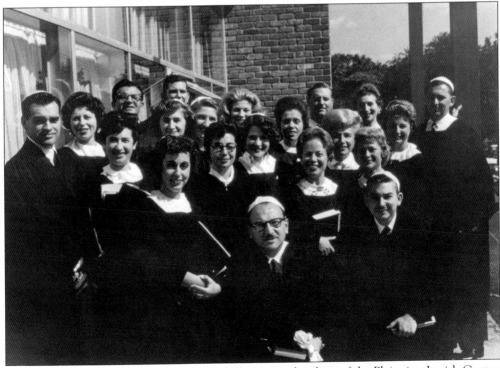

Howard Silfin (back row, fourth from the left) sang in the choir of the Plainview Jewish Center. The choir is shown just before Rosh Hashanah 1962. Silfin was also chair of the ritual committee of the synagogue, which Silfin's parents joined in the late 1950s. Silfin's father remained active until his death in 1987. (LS.)

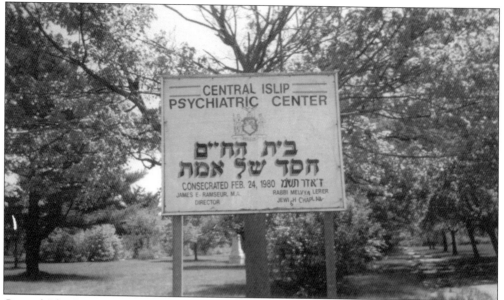

Central Islip State Hospital was the first of the three large psychiatric hospitals to be built in Suffolk County. After decades of itinerant clerical services to patients, in 1976, Rabbi Melvyn Lerer became the state-appointed rabbi at this institution. He claims he has the largest and most unique congregation. He can regale with stories about how he has helped patients in a variety of ways. One of Lerer's important accomplishments was to designate a Jewish section of the hospital cemetery, thereby providing dignity to those who might need it most. Recently, Touro Law Center, whose new building is adjacent to the cemetery property, has assumed responsibility for restoration. The gates shown below have been repainted. The North Shore Jewish Center Men's Club does an annual cleanup and *yizkor* service for the interred. (Both, RM.)

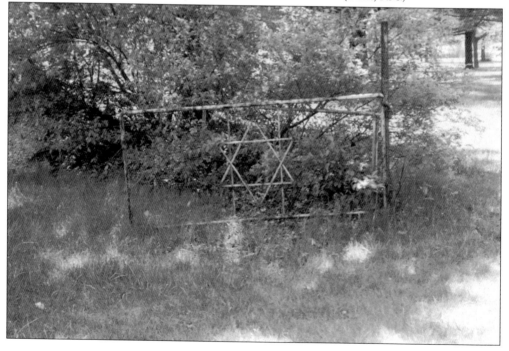

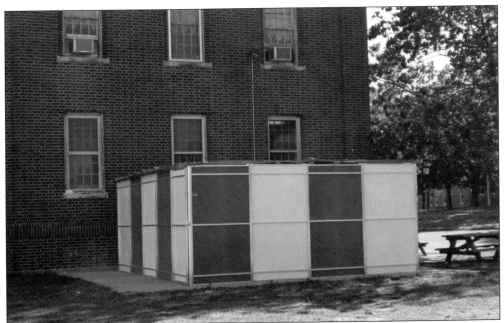

Pilgrim State Hospital opened in 1931 in response to overcrowding conditions in the other two large New York State psychiatric hospitals on Long Island. Rabbi Melvyn Lerer, who had been the rabbi at Central Islip State Hospital until it closed in 1996, was relocated to Pilgrim. Although the hospital is currently greatly reduced in size, Rabbi Lerer continues there serving the Jewish population in the above *sukkah*, a temporary shelter symbolic of the Succoth holiday built to celebrate the harvest season. Below, the Hebrew carved into the concrete serving as the sukkah platform reads: "With the help of Heaven (G-d) – Sukkot – 5758/1994." (Both, RM.)

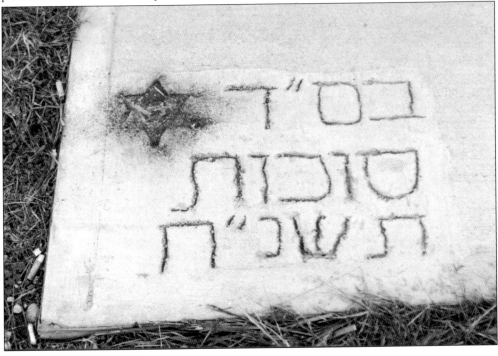

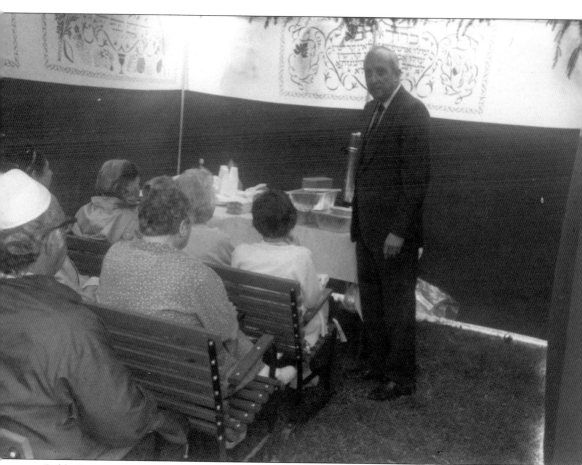

Rabbi Lerer is pictured inside the sukkah performing ceremonial duties during the Sukkot holiday season. At Central Islip State Hospital, Rabbi Lerer was proactive in offering opportunities for patients to participate in Jewish celebration. During Sukkot, Jewish celebrants typically eat their meals in open-air structures after a short religious ceremony. (NYSOMH.)

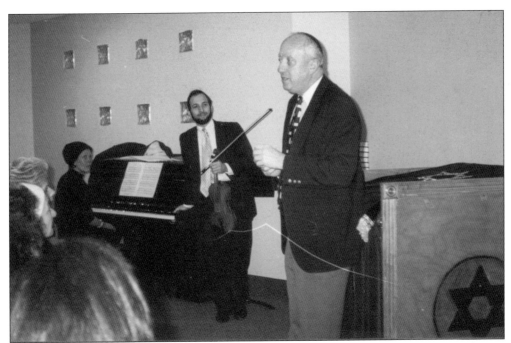

A violinist at the East Northport Jewish Center performs for patients from the Pilgrim Psychiatric Center. Rabbi Lerer, pictured above, was instrumental in arranging such events. Serving since 1976, Rabbi Lerer is the longest serving rabbi in the New York State hospital chaplaincy system. The East Northport Jewish Center, a Conservative synagogue established in 1956, hosted events for patients of the Pilgrim Psychiatric Center. Patients were transported to the synagogue for a celebratory outing that also provided observance of Jewish holidays. Below, patients are dancing at a Hanukkah party. (Both, NYSOMH.)

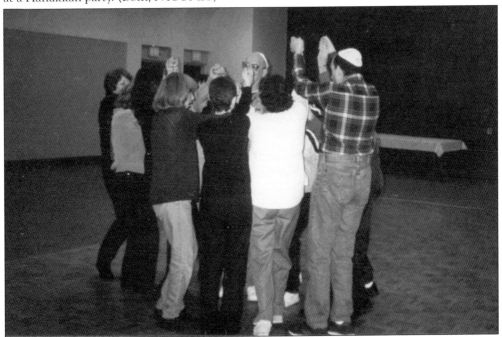

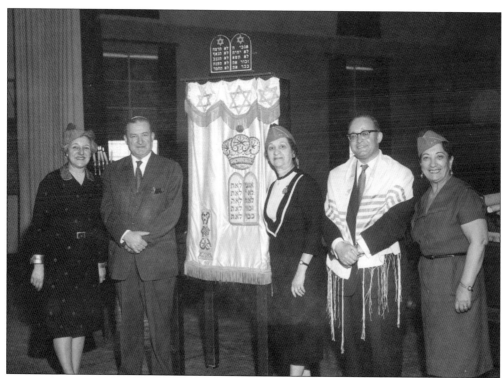

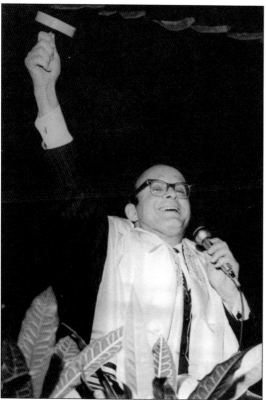

Rabbi Wachtfogel served as itinerant rabbi for about two decades to Jewish patients of the Kings Park Psychiatric Hospital before the formation of the New York State chaplaincy position. In the 1960s photograph above, the Holy Ark containing the Torah is surrounded by the rabbi and volunteers from the Ladies Auxiliary of the Jewish War Veterans. (Photograph by Al Musson, KPHM.)

Rabbi Wachtfogel joyously twirls a *grogger* in a 1970s Purim celebration at the Kings Park Psychiatric Hospital. Purim celebrates the biblical Book of Esther. In this tale of heroism, Esther's uncle Mordecai uncovers the wicked Haman's plot to murder the Jews. While retelling the story, every time the name "Haman" is mentioned, noisemakers are twirled to drown out the evil man's name. (Photograph by Philip S. Stasuk, KPHM.)

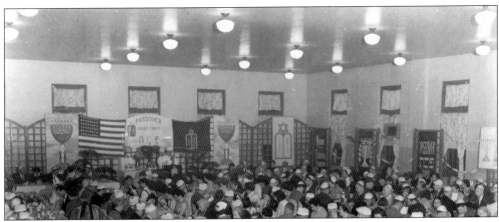

York Hall, the auditorium and recreation center for Kings Park State Hospital, was the location of *seders* serving hundreds of patients (possibly not all Jewish) during the Passover holiday. Above, the large crowd and holiday decorations can be seen as patients are sitting along beautifully set, food-laden tables. From this and other 1960s photographs of such events, it is evident that the Jewish War Veterans were instrumental in assisting with these occasions. As early as 1935, as can be determined from the memorandum below, the Jewish Welfare Board indicated that the US Veterans facility at Northport provided for 120 Passover meals at a cost of $69.40. (Both, KPHM.)

JEWISH WELFARE BOARD - OFFICE MEMORANDUM

From	To	Date
MR. ABELSON	MR. KRAFT	October 30, 1935

In Re: High Holy Day Expenditures - U.S. Veterans Facility, Northport, L. I. and Kings Park State Hospital, Kings Park, L. I.

Under date of October 26th Rabbi Samuel Casson, our representative for the U. S. Veterans Facility, Northport, Long Island, and Kings Park State Hospital, Kings Park, Long Island, submitted vouchers totaling $69.40 for 120 packages containing special Passover food, which were distributed to 120 veterans at these institutions.

Last year the sum of $68.85 was expended. I recomment the approval of the present expenditures incurred.

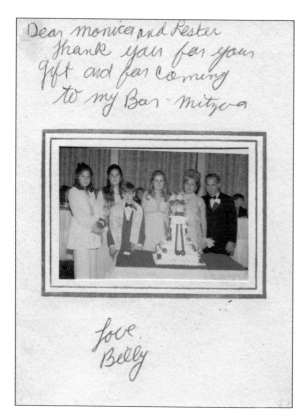

Dear monica and Lester
thank you for your
gift and for coming
to my Bar-mitzva

love,
Betty

An important Jewish coming-of-age ceremony is the bar and bat mitzvah. This image features a typical bar mitzvah thank-you note. William Kremer of Hewlett joked that his handwriting was better in 1969 than it is today. Pictured are members of the Kremer family: Alys, Betty, bar mitzvah boy William, Edith, and proud parents Anna and Michael. This is an especially poignant moment, as both Anna and Michael were Holocaust survivors. To have a bar mitzvah son was beyond their wildest dream. (LG.)

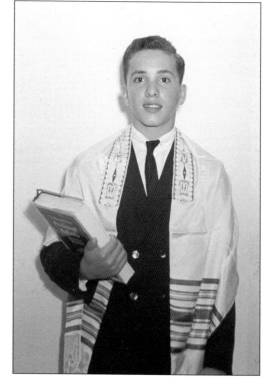

On September 5, 1964, at the East Meadow Jewish Center, Arthur Kurzweil, son of Saul and Evelyn Kurzweil, publicly celebrated his bar mitzvah and privately celebrated the end of his pre–bar mitzvah Jewish education at the synagogue. Arthur grew up to become an author of Jewish books and a Jewish educator, even though, as he states, he "intensely disliked Hebrew school." (AK.)

Jerome and Rona Seperson and family moved to Polo Road in Great Neck around 1950 and became active members of Temple Emanuel of Great Neck. The 1962 bar mitzvah of their son Robert was held at that synagogue, while the reception was held at Leonard's of Great Neck, a popular catering establishment at which many bar mitzvah and Jewish wedding receptions were held. Robert's wedding to Susanne Bleiberg occurred on March 16, 1975, at the Great Neck Synagogue, where the reception was also held. Robert and Susanne Seperson continue to live on Long Island, where they raised their three children. (Both, RS.)

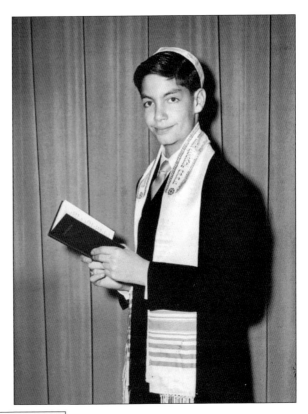

Mr. and Mrs. Jerome R. Seperson
request the honour of your presence
at the Bar Mitzvah of their son
Robert
on Saturday, the tenth of November
nineteen hundred and sixty-two
at half after ten o'clock
Temple Emanuel of Great Neck
Hicks Lane and Station Road
Great Neck, New York

Reception at one o'clock
Leonard's of Great Neck
555 Northern Boulevard

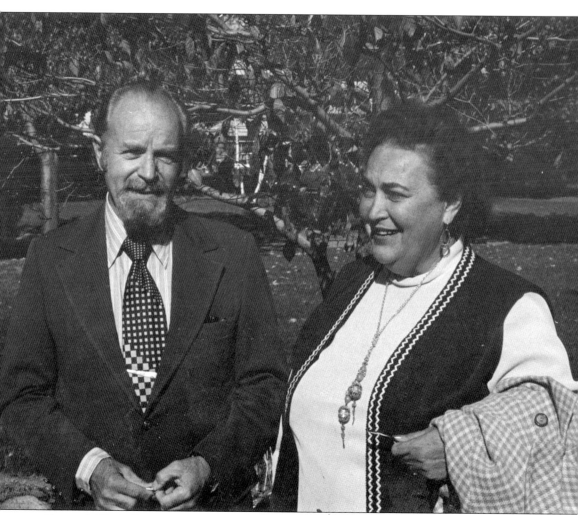

Ben and Gloria Bernstein are pictured after September 1965 Rosh Hashanah services in the backyard of their Woodbury home. They were able to move to this more upscale home in the Gates at Woodbury community in 1960 from their first home in Hempstead, thanks to Ben's successful home decorating business in the late 1950s. (WB.)

The bar mitzvah of William Bernstein and reception were held on October 19, 1957, at the Uniondale Jewish Center. The invoice for the reception (above) was priced at $605 for 100 guests. The menu, typical of the era, included egg rolls, franks in blankets, cocktail *knishes*, chopped liver, *kishka*, and glazed brisket of beef. Entertainment was provided by comedian Lou Mason, a well-known personality of the time. The check below, made out to the Uniondale Jewish Center, is believed to be payment for the $60 fee paid to Mason. (Both, WB.)

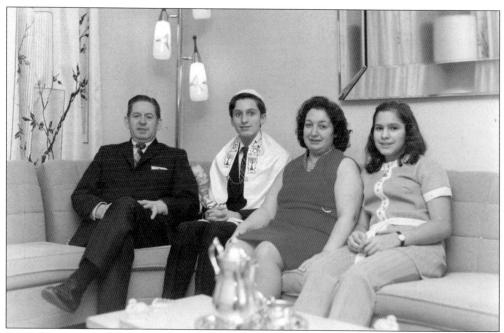

Frank Mann, son of George and Kitty Mann, became a bar mitzvah on January 4, 1971, at the Farmingdale Jewish Center. The family portrait above, taken in the Mann home, also shows Mann's sister Lorraine. The bar mitzvah reception was held at the Huntington Town House, a popular location for many Jewish family events. The photograph below shows the family during the prevailing tradition of a candle-lighting ceremony. (Both photographs by Theodore Horishny, GM.)

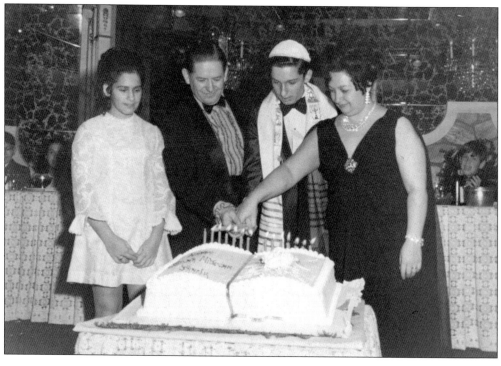

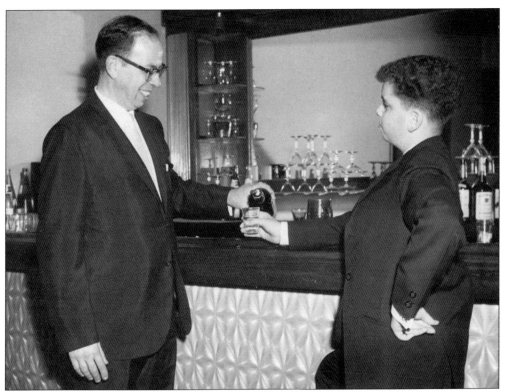

Gary Garber celebrated his bar mitzvah at the Midway Jewish Center in Syosset. The bar and bat mitzvah ceremonies mark the emergence of a youth to an adult with the duties of performing Jewish religious obligations. A traditional statement to bar mitzvah boys is "Today you are a man." Morris Garber emphasizes that proclamation by proudly serving a drink to his son Gary at his bar mitzvah party, above. Below, guests dance the traditional *hora*, a mainstay of Jewish celebratory events. In the center of the hora dance ring, Gary is dancing with his mother, Tess, as his father, Morris, smiles joyously from the circle of dancers. (Both, TPG.)

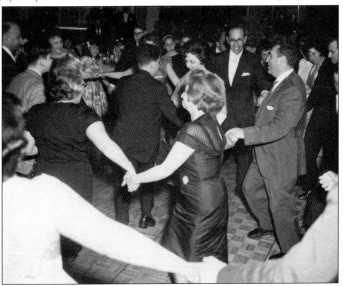

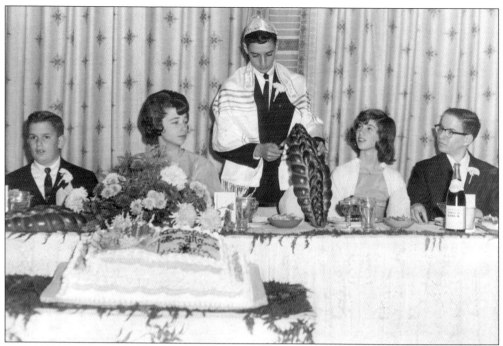

Victor Mark Susman, son of Israel Leo and Evelyn Lamm Susman, became a bar mitzvah on December 2, 1962, at Temple Hillel in Valley Stream. Temple Hillel was established in 1955 when only 50 of 1,000 homes were built in the planned community of the North Woodmere area of Nassau County. The interest in starting a synagogue is a strong indicator of the Jewish community that was attracted to the area. Above, Susman is cutting the challah, an honor of having become a man, as his friends and family watch. The bar mitzvah cake sits on a table in front of the dais. The photograph below shows the traditional symbols of a Jewish religious event: *tallis* and bag, *yarmulke*, prayer book, and the bar mitzvah invitation. (Both, VMS.)

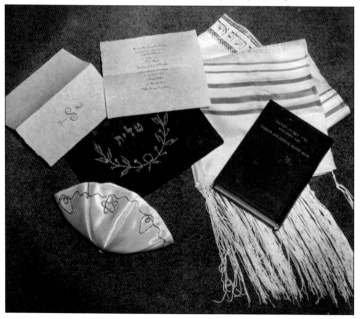

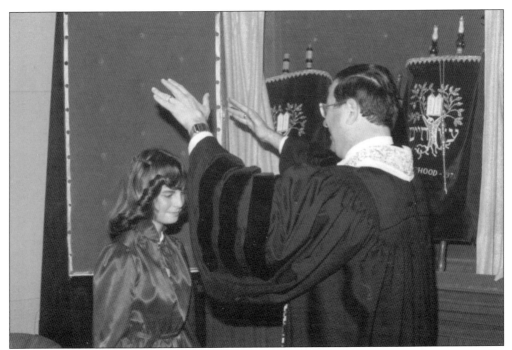

Although the first Reform bat mitzvah in America occurred in 1922, it was quite uncommon for girls to observe that milestone until the 1970s. At Sinai Reform Temple in Bay Shore, bat mitzvah Suzanne Miller is blessed by Rabbi Joel C. Dobin using the traditional hand gesture in front of the open ark. Dobin served the congregation from 1965 to 1981. (RM.)

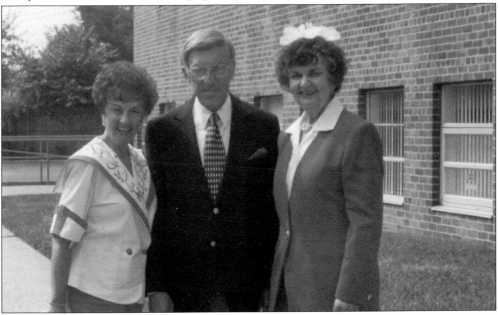

Tess Garber, longtime member of the Midway Jewish Center in Jericho, was able to fulfill a lifelong desire—that of becoming a bat mitzvah. In 1993, at age 70, Tess Garber became a bat mitzvah at the Midway Jewish Center. In this photograph taken in front of the synagogue, her brother Manuel Pierce and sister Ecille Pierce Shapiro share the occasion. (TG.)

REPORT TO PARENTS

"The Home and the School should work together
for the good of the child."
926 ROUND SWAMP ROAD
PLAINVIEW, NEW YORK

Temple Beth Elohim
RELIGIOUS SCHOOL

Name Hayne, Mitchell

Grade 6 Promoted to Grade

STUDIES AND ACTIVITIES	1ST TERM CHANUKAH	2ND TERM PURIM	3RD TERM SHAVUOT
BIBLE Torah Topics	E	G+	E
CEREMONIES	E	E	E·+
ETHICS AND PERSONAL ADJUSTMENT			
HEBREW			
THE JEWISH PEOPLE	G+	E	E
POST-BIBLICAL JEWISH LITERATURE AND CULTURE			
THEOLOGY			
WORSHIP			
Current Events	E	E	E
CONDUCT	E	E	G
EFFORT	E	E	E
NO. OF DAYS IN TERM a. One day a week school	11	8	9
b. Two } day a week school Three }			
NO. DAYS ABSENT	1	1	0
NO. TIMES LATE			

E—Excellent G—Good F—Fair P—Poor

PUBLISHED BY UNION OF AMERICAN HEBREW CONGREGATIONS, NEW YORK
02

Religious education is important in Jewish culture. Mitchell Hayne, son of Jack and Pearl Hayne, attended religious school at Temple Beth Elohim of Old Bethpage one day a week. Typically, that one day was a Sunday. In his sixth-grade, 1969 report card, it can be seen that the marking periods were based upon holidays: Hanukkah, Purim, and Shavuot. Temple Beth Elohim of Old Bethpage, a Reform congregation, was established in 1955. The name of the new congregation was determined by the donation of a Holocaust Torah from Temple Beth Elohim of Brooklyn. By 2013, demographics changed and the congregation merged with the North Shore Synagogue in Syosset. (Both, JH.)

TEACHER'S COMMENTS

FIRST TERM CHANUKAH Mitchell is uniformly well prepared each week and shows a high level of interest. Average test scores, here, are a disappointment in view of his weekly effort. Handcraft projects are nicely done + appreciated.

SECOND TERM PURIM Pleased to report as stated.

THIRD TERM SHAVUOT It was a pleasure to have Mitchell this year.

This report will keep you in touch with the work of the children and will be an aid to further cooperation. It is only through intelligent, wholehearted cooperation between parents and school that the aims of Jewish Education can be realized. Please examine carefully reports and comments of the teachers, and cooperate by encouraging your child in his work and by stimulating his interest in the Jewish school.

Parents are cordially invited to confer with the teacher, the principal, the educational director or the rabbi.

TEACHER

SIGNATURE OF PARENT OR GUARDIAN

FIRST TERM
DATE 1/5/69 Signed Jack R Hayne

SECOND TERM
DATE 4/15/69 Signed Jack W Hayne

THIRD TERM
DATE Signed

The 1967 religious school class photograph above of Temple Beth Elohim of Old Bethpage features Steve Bishop (back row on the right), who was the teacher, temple organist, and choir director. Mitchell Tod Hayne stands in the top row at left. In the 1969 confirmation class photograph below of Temple Beth Elohim of Old Bethpage is Dr. Louis Stein (top center), the rabbi for well over 40 years. Bennett Golub is on the left in the second row next to Mitchell Tod Hayne. Golub and Hayne were good friends who became bar mitzvah on the same day and therefore were unable to attend each other's reception; Golub's was at the Galaxy in Plainview, and Hayne's was at the Huntington Town House. (Both, JH.)

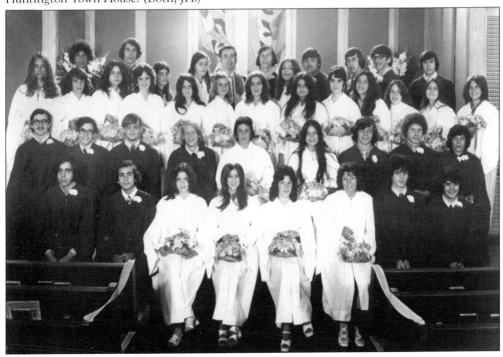

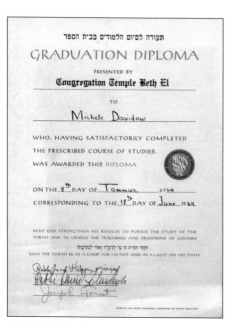

תעודה לסיום הלמודים בבית הספר

GRADUATION DIPLOMA

PRESENTED BY

Congregation Temple Beth El

TO

Michele Davidow

WHO, HAVING SATISFACTORILY COMPLETED
THE PRESCRIBED COURSE OF STUDIES,
WAS AWARDED THIS DIPLOMA

ON THE 8th DAY OF Tammuz 5724
CORRESPONDING TO THE 18th DAY OF June 1964

MAY GOD STRENGTHEN HIS RESOLVE TO PURSUE THE STUDY OF THE
TORAH AND TO UPHOLD THE TEACHINGS AND TRADITIONS OF JUDAISM

ויהי תורת ה' נר לרגלי ואור לנתיבתי

"MAY THE TORAH BE AS A LAMP FOR HIS FEET AND AS A LIGHT ON HIS PATH"

Michele Davidow, daughter of Sanford and Saundra Davidow, graduated from the Hebrew school at Congregation Temple Beth-El in Patchogue when she was about 13 years old. Her grandfather Harry A. Davidow was one of the founding members and the attorney for the fledgling congregation. Davidow represents the third generation of members in the congregation. (HH.)

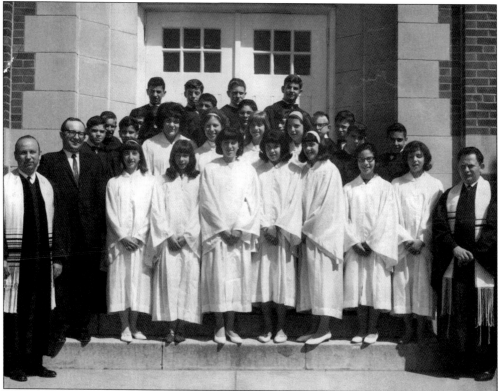

Standing with the 1965 graduation class of Temple Beth-El of Patchogue is Rabbi David Shudrich (far left), whose son Michael Shudrich is the current chief rabbi of Poland. At far right is Cantor Nathan Bryn. The photograph was taken in front of the original front doors of the synagogue. That space is now covered by a mosaic panel that was commissioned to artist Willet Ryder around 2000. (TBP.)

John Paul Lowens (back row, left) stands next to Rabbi Abram Vossen Goodman in this 1959 confirmation class photo. Goodman served at the (now defunct) Reform Temple Sinai in Lawrence from 1952 to 1966 and as emeritus for decades later. A Harvard graduate and an early officer of the American Jewish Historical Society, his specialty was Jewish history in the Revolutionary War period. Rabbi Goodman was succeeded at Temple Sinai by Rabbi Martin Segal. (JPL.)

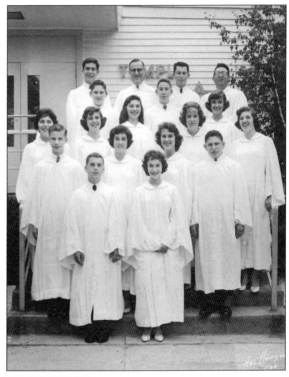

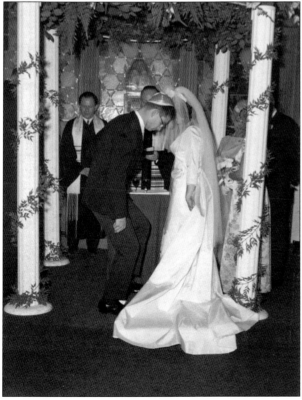

The breaking of a glass is a traditional part of a Jewish marriage ceremony. Under the *chuppah* are bride Susan Ashare and her new husband, Irvin Privler. The couple married on December 18, 1966. Both the wedding and the reception occurred at the Huntington Town House, a popular catering establishment of that era. (SP.)

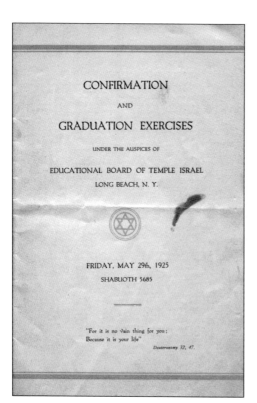

CONFIRMATION

AND

GRADUATION EXERCISES

UNDER THE AUSPICES OF

EDUCATIONAL BOARD OF TEMPLE ISRAEL

LONG BEACH, N. Y.

FRIDAY, MAY 29th, 1925

SHABUOTH 5685

"For it is no vain thing for you;
Because it is your life"

Deuteronomy 32, 47.

In 1925, a program for the Temple Israel confirmation class marked their graduation from religious school, and the first graduation class from their new building. In that era, females were not permitted to be a bat mitzvah, but confirmation was acceptable. The back page of the program (below) lists the considerable number of people and offices who contributed to the success of the graduating students. This event occurred under the spiritual leadership of Morris M. Goldberg, who expanded the congregation's religious school to weekday and Sunday lessons. Within three years, the school flourished to the point of needing a new building. (Both, LBHPS.)

EDUCATIONAL BOARD

HENRY S. NADELWEISSChairman
HARRY O. SANDBERGSecretary
IRVING GARSONTreasurer

BOARD MEMBERS

Herman Weinberger Nathan E. Superior
Saul K. Wolff

ADVISORY COMMITTEE

Charles L. Apfel Israel Cummings
Charles Silver Morris Feinberg
Rabbi M. Goldberg

REPRESENTATIVES OF
TEMPLE ISRAEL SISTERHOOD

Mrs. Israel Cummings Mrs. Irving Garson
Mrs. Joseph Wolfman

DEPORTMENT AND WELFARE COMMITTEE

Mrs. Ben. Cohan Mrs. Irving Garson
Mrs. Louis Englander Mrs. Joseph Wolfman
Mrs. Herman Weinberger Mrs. Nathan Superior
Mrs. Ralph Herschcopf Mrs. Henry S. Nadelweiss
Mrs. Israel Cummings Mrs. Frank Frankel

FACULTY

MORRIS M. GOLDBERGRabbi
JOSEPH KRENDELPrincipal
ELIZABETH WEINTRAUBTeacher
NELLIE HANESTeacher

PRINTED BY H. J. RUCHBERGER, 740 WEST PENN STREET, LONG BEACH, N. Y.

Three

EXPANDING THE JEWISH SOCIAL COMMUNITY

With the growth of Jewish religious populations, there was a parallel growth in Jewish affiliated social organizations such as Hadassah, Organization for Rehabilitation through Vocational Training (ORT), new chapters of the Jewish War Veterans, United Jewish Appeal, Zionist Organization of America, America Israel Public Affairs Committee, American Jewish Committee, Women's League for Israel, and American Friends of Magen David Adom. The 1950s through the 1980s were the "golden years" of a Jewish presence on Long Island.

Several communities on Long Island became distinctly Jewish: Great Neck, Dix Hills, and Plainview, among others. Public schools throughout Long Island were closed for Jewish holidays. Passover was often taken into consideration for the spring break that had traditionally focused around Easter. Jewish integration into the larger community was an important concept. Colleges on Long Island such as Hofstra University and the State University of New York at Stony Brook formed Hillel groups, thereby ensuring a Jewish presence on campuses as well as serving the religious needs of students.

During World War I and World War II, Camp Upton in Yaphank was an important regional induction and training station. The songwriter Irving Berlin was stationed there during World War I. The experience inspired him to write *Yip Yip Yaphank*, a musical revue of Army life. After World War II, the increasing presence of Jewish war veteran posts became an extension of the veterans who were able to purchase affordable Long Island homes under the GI Bill. These veteran posts served both a social and community function.

In 1948, the new state of Israel was the pride of the Jewish people. Many Jews purchased Israel bonds and donated other forms of support for the new state. Students from religious schools collected money in charity boxes and purchased trees for the Jewish National Fund to develop barren land in Israel. During the Six Day War of 1967 and the Yom Kippur War of 1973, Jews donated ambulances and other items of need.

Overall, there was a vibrant and vital social Jewish community on Long Island that extended well beyond synagogue life.

STATISTICS OF GROWTH

LOCATIONS STAFF

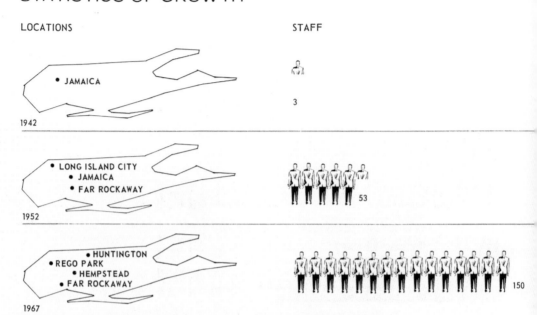

The rapid growth in the number of Jews residing on Long Island had a multitude of rich benefits. However, this growth also meant that more people had need for social services. In 1956, the Jewish Community Services of Long Island opened a Nassau County office in Hempstead. By 1965, they needed to open a Suffolk County office in Huntington. This chart illustrates the growth of the agency in terms of staffing, families served, and expenditures. Services from the agency included

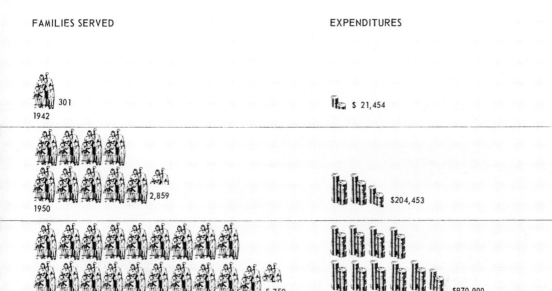

FAMILIES SERVED

EXPENDITURES

301
1942

$ 21,454

2,859
1950

$204,453

5,750
1967 (est.)

$970,000

family and child counseling, financial assistance, institutional placement, and assistance to the aging. Previously under the aegis of the Federation of Jewish Philanthropies, in 1990, the agency merged with the Federation of Employment and Guidance Services (FEGS) and operated under the new name Jewish Board for Family and Children's Services. (HUSPCOL/LISI.)

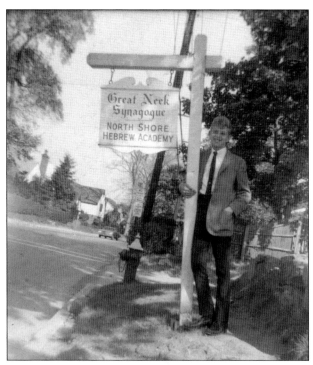

In the 1950s, Hebrew day schools, such as Hillel Hebrew Academy, opened on Long Island. These schools catered to the growing traditional Jewish communities. The North Shore Hebrew Academy in Great Neck, established in 1954, grew through the efforts of Rabbi Dr. Ephraim Wolf, who went door to door recruiting students. The school matured from preschool and elementary grades to eventually include a middle and high school. In the photograph at left, Martin Goldwyn stands alongside the original sign. The photograph below shows a 1957 class. Other Jewish day schools established at this time are the Schechter School of Long Island and the Hebrew Academy of Nassau County. (Both, SG.)

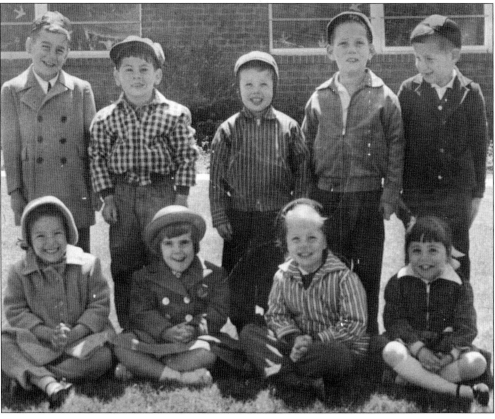

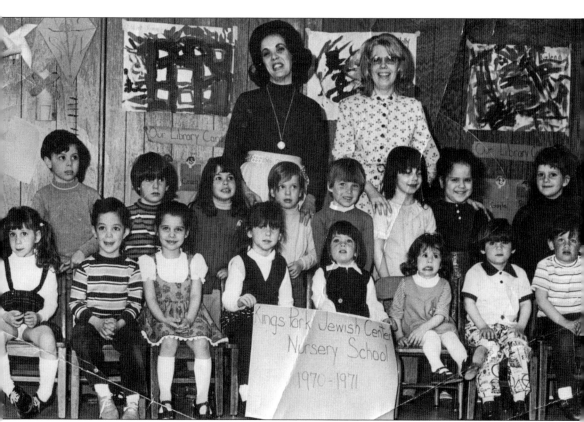

After the 1962 fire, the Kings Park Jewish Center was rebuilt on Route 25A. The synagogue was now large enough to accommodate more community services. On the lower level, a nursery school was sponsored by the synagogue. This 1970–1971 class photograph of 16 children and two teachers attests to the popularity and need of the preschool program. (KPHM.)

HILLEL

First row: Stella Stohlman, Mark Essner, Arlene Siegel, Mary Kutchen. Second row: Peggy Ames, Audrey Samuels, Santo Vogel, Don Avrick, Allen Chergun, Martin Salvage. Third row: Allen Goldsant, Herbert Hert, Harold Shapiro, Jerry Tucker, Norm Siegel.

Hofstra University in Hempstead has a longtime Hillel organization on its campus, as evidenced by this 1950 *Nexus* yearbook photograph. Hillel, which is not religiously restrictive, provides a place where there is socialization, community service, Jewish holiday celebration, and kosher food as the students' needs dictate. Hillel continues as an active Hofstra student association. Hillel is partially supported by the United Jewish Appeal Federation of New York. (HUA.)

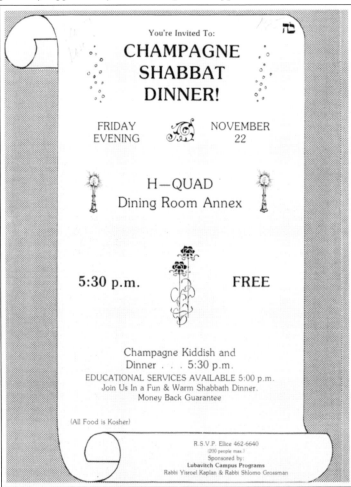

You're Invited To:

CHAMPAGNE SHABBAT DINNER!

FRIDAY EVENING NOVEMBER 22

H—QUAD
Dining Room Annex

5:30 p.m. FREE

Champagne Kiddish and
Dinner . . . 5:30 p.m.
EDUCATIONAL SERVICES AVAILABLE 5:00 p.m.
Join Us In a Fun & Warm Shabbath Dinner.
Money Back Guarantee

(All Food is Kosher)

R.S.V.P. Ellice 462-6640
(200 people max.)
Sponsored by:
Lubavitch Campus Programs
Rabbi Yisroel Kaplan & Rabbi Shlomo Grossman

In 1955, the Lubavitch Youth Organization was founded by Rabbi Menachem Schneerson. The organization provides student programming fostering Jewish life, coordinates spring break service trips, and develops relationships with partner organizations to further Jewish life on campus. This flyer from Stony Brook University represents one of the many services provided to Jewish students at Long Island campuses. (UASBUL.)

A Jewish student organization was established at the State University of New York at Stony Brook in 1964, and in 1966, the group became a formal Hillel affiliate. Hillel is a pluralistic Jewish organization representing all aspects of Jewish life on campus: religious, cultural, educational, social, community service, Zionism, advocacy, and student leadership development. Stony Brook Hillel began with a part-time rabbi and now provides six professionally trained staff members to serve the university community. Hillel was a founding member of the University Interfaith Center in 1975 and became an agency of UJA-Federation of New York in 1983. As Stony Brook University has grown, so Hillel has expanded and currently serves about 2,500 Jewish students. Hillel is located in the Gloria and Mark Snyder Hillel Center in the Stony Brook Student Union. (Both, HF.)

THE JEWISH STUDENT ORGANIZATION

of

THE STATE UNIVERSITY OF NEW YORK
at Stony Brook

cordially invites you to attend

The Dedication of its

B'nai B'rith Hillel Counselorship

Sunday, February 12, 1967
at 10:30 a. m.

Faculty Dining Room on Campus

Brunch Will Be Served

Donation $1.75

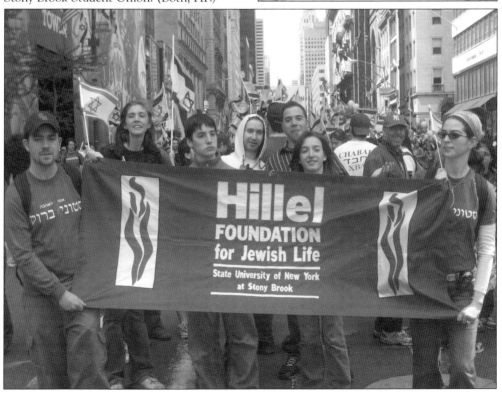

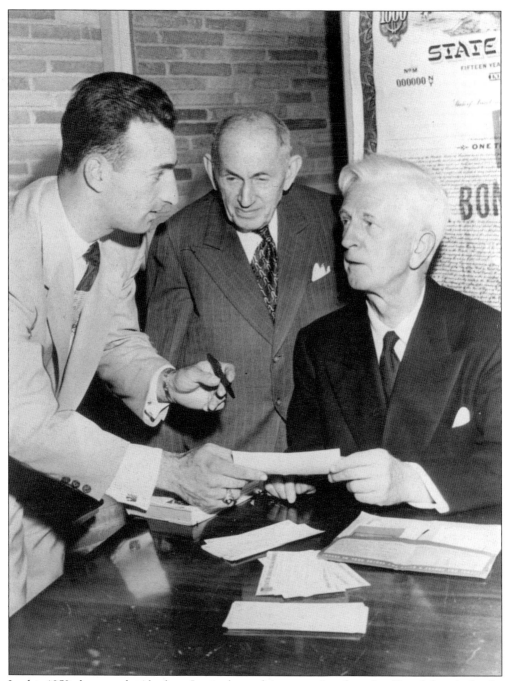

In this 1952 photograph, Abraham Levitt (center) is supporting the sale of Israeli bonds. In the early 1950s, bonds were floated to support the fledgling state of Israel, which had severe economic problems due to a war immediately after its declaration of independence. In addition, the volume of Holocaust survivors and 500,000 Jews expelled from Arab countries pouring into Israel was economically burdensome. (LPLHC.)

The Robert K. Toaz Junior High School in Huntington was the first junior high school to be built in Suffolk County and one of three junior highs in the district at the height of enrollment. However, by 1965, enrollment began to decline and the building was eventually sold to the Touro Law Center, which already had a presence in New York City. Touro is one of two law schools following Jewish tradition in the nation, and thus represents an important Jewish presence on Long Island. In 2007, Touro Law Center moved to a new facility adjacent to the Central Islip court complex. (Both, TLC.)

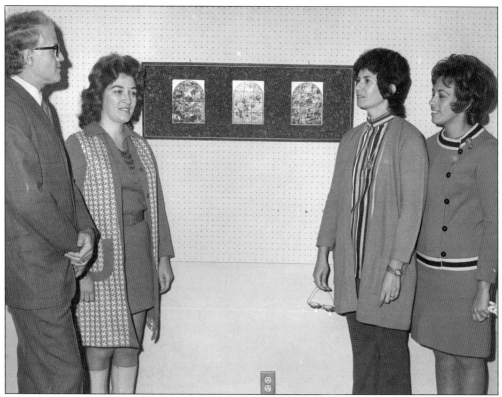

The Tobay chapter of Hadassah was formed in 1954 by a group of women who were adjusting to suburban living. In 1971, the chapter made a donation of copies of Chagall prints to the Plainview–Old Bethpage Public Library. Pictured from left to right are Stanley T. Eddison, Elsie Kochner, Joan Grossman, and chapter president Helen Spector. (POBPC.)

Isabella Goldschmidt is awaiting her cue backstage to ascend the runway during a Hadassah fashion show in Levittown. Many social, community, and charitable organizations flourished in Levittown in the 1950s and 1960s. Goldschmidt was active in ORT until her late 80s and ran the office for her husband's cosmetic manufacturing factory, Fern Laboratories. (LG.)

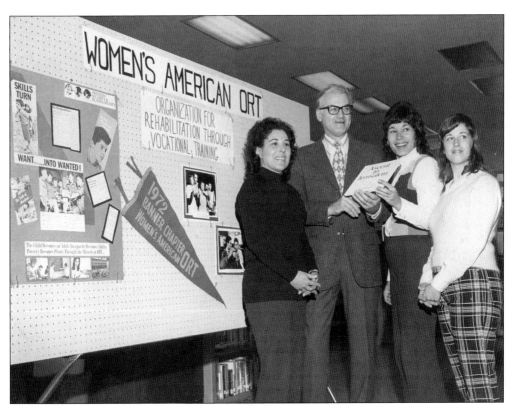

In 1972, the Plainview chapter of ORT presented the book *Ascent to Jerusalem* to the Plainview–Old Bethpage Public Library. Pictured accepting the book is Stanley T. Goodwin. Women's American ORT grew exponentially with Long Island suburban growth as a fundraising and community service organization. (POBPC.)

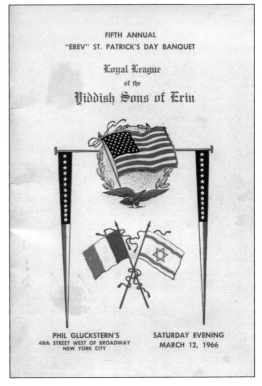

The Loyal League of the Yiddish Sons of Erin met annually on the night before the New York City St. Patrick's Day Parade. This event was held at Phil Gluckstern's, a popular kosher restaurant in Manhattan. George Mann, of Farmingdale, was an associate member. His wife, Kitty, has family roots in the United Kingdom. (GM.)

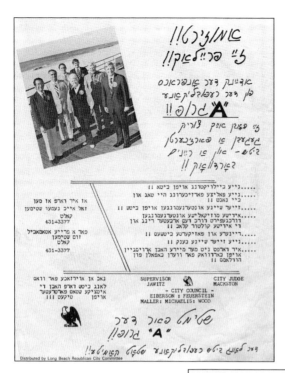

In the late 1960s, the Long Beach Republican City Committee viewed the Jewish population of Long Beach important enough to produce a Yiddish language flyer. While the flyer promotes Republican leadership, it largely announces that Long Beach is a community with Yiddish cultural events. In the last of the bullet points, it announces that "you need no longer fear going out on the boardwalk and being attacked by hoodlums." (LBHPS.)

In 1967, the Mid-Island Y-JCC (Jewish Community Center) proudly announced the property purchase for its new Plainview building. The Mid-Island Y, as it is known, started in 1956 and quickly outgrew the residential home in which it was quartered. The organization actively continues today as a community center of Jewish life. The Jewish Genealogy Society of Long Island has been meeting at this facility for most of its 30 years. (HUSPCOL/LISI.)

Y NEWS

PUBLISHED BY THE MID-ISLAND YM & YWHA

Affiliated with the Associated YM-YWHAs of Greater New York; A Subvention Agency of the Federation of Jewish Philanthropies of New York; A Member Agency of the National Jewish Welfare Board, the United Fund of Long Island, and the Health and Welfare Council of Nassau County

Vol. 10, No. 1 June, 1967 — Sivan, 5727 Wantagh, L. I., N.Y.

MID-ISLAND Y PLANS NEW BUILDING

CONTRACT FOR LAND SITE SIGNED

A contract to purchase a site for a new building for the Mid-Island YM & YWHA has been signed by George Groner, president of the Y. The site consists of 4.7 acres and is located on the Dauernheim Nursery on Jerusalem Avenue in Wantagh, about one quarter-mile east of Wantagh Avenue. The site, near the Wantagh-Oyster Bay Expressway, Southern State Parkway and Sunrise Highway will be readily accessible to a wide geographic area. A special use permit for the site has been granted by the Board of Zoning Appeals of the Town of Hempstead.

Proposed for the new site is a major $2,500,000 cultural, recreational and informal education center to serve all age levels. The new center will consolidate the Y's facilities and program into one building and will provide a broad range of services for the benefit of the communities in the eastern section of Nassau County.

Facilities Proposed

Among the facilities being planned are separate lounges for varied age groups, a large gymnasium and health club, exercise room, a sizable auditorium, and club rooms. There is to be an olympic size swimming pool, ceramic and woodworking shops, art studio and drama workshops, outdoor play area, and a fully-equipped nursery school.

Serving youth will remain as one of the Y's priority goals. There is a great need for a place where youth will have the opportunity to meet with each other, learn the ways of democracy, learn the give and take of living, and have fun. Service will also include programs for pre-schoolers, school-agers, young adults, young married couples, families, adults, and older adults.

Rapid Growth of the Y

The Mid-Island Y was started a little more than ten years ago in June,

President of the Mid-Island YM & YWHA, George Groner, signs contract to purchase site for new Y building. Seated beside Mr. Groner is Sidney Solomon, Chairman of the Land Committee of the Board of Directors of the Y. Standing left to right are Alvin Silverman, a member of the Land Committee, and Percy Abrams, Executive Director of the Y. Negotiations for the site were initiated during the presidency of William Lewi, immediate past president.

1956 by a handful of dedicated parents. It has grown faster even than Nassau County — so that today, it serves 1,000 families. The residential house on Wantagh Avenue used as Y headquarters is now totally inadequate. A rented swimming pool located some distance away can't accommodate all of those who would use its facilities. Other sites in local schools serve as the Y gymnasiums, little theatre and auditorium.

By consolidating into one headquarters, the new Mid-Island Y will be able not only to provide a year-round program, but to greatly extend its total service to the community.

How Funds Will Be Raised

The 32 member Board of Directors, including several no longer resident in the area but still active, spearheaded the move for a new facility. Many members of the board have given generously both in time, energy and

funds and will spearhead this activity. New board members are being sought to add strength to the present group and participate in development of the new structure.

Support for the campaign is visualized as coming from three major sources. The first will be the local effort to secure contributions. This has already begun. A fair share goal for the local communities has been set at $500,000. The object will be to secure voluntary pledges of $500 from each of 1,000 individuals or families. Pledges are payable over a five year period and all contributions are tax deductible. This local effort and dedication will be vital to the success of the project. Chairman of the local campaign is Mr. William A. Leviton, of the Board.

The second source will be the Associated YM-YWHAs of Greater New

(continued on page two)

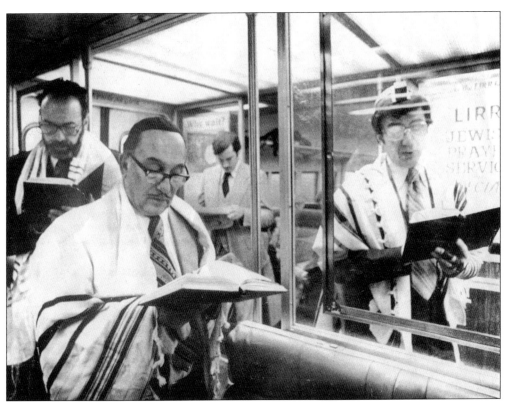

An attraction to living in Long Beach is its proximity to New York City and easy commute via the Long Island Rail Road. In 1977, an experiment to conduct prayer services was instituted in the first car of the 7:08 train from Long Beach. Another group, who studied a page of the Talmud every day, finished the Talmud after 72 years of continuous study on the commuter train. (LBHPS.)

LONG BEACH
TELEPHONE DIRECTORY
PUBLISHED BY
THE SISTERHOOD of TEMPLE EMANU-EL

Lad 'n' Lassie
Apparel & Accessories
For Girls in Sizes
3 - 6
7 - 14
10-14 Petiteen
10 - 16 Teen

100 W. PARK
corner
NATIONAL
BLVD.

L. B. 6-
0960

Temple Emanu-El of Long Beach flourished during the 1950s. As part of the congregation's commitment to the community, the annual publication of the Long Beach Telephone Directory by the sisterhood commenced during this time. Through this publication, the congregation was known to every home and business in Long Beach. (LBHPS.)

73

Driving Blind — Aaron Kramer

If I could believe that the mist
within my soul might lift
 one morning
As the fog does now,
If I could hope that some such
 lyrical feast might slowly un-
 fold,

That branch by branch
a race of radiant elms
Would rise before my eyes.
Each grateful head upraised
 unto the east,

Then without a quiver of cold I'd
 gaze
Into the gray around me everywhere
The driving blind I'd murmur not
 despair,
But as a prayer:
Good haze, kind haze I thank thee
 for thy gift —

Bury it, bury me now,
But later — lift!

Aaron Kramer (1921–1997) was a beloved English professor at Dowling College in Oakdale from the time it became independent from Adelphi Suffolk in 1968. In addition to his role as educator, Kramer was a widely published poet and an important translator of Yiddish poetry. In 1944, with his first widely acclaimed publication in *Seven Poets in Search of an Answer*, Kramer gained national attention for works that spoke to his readers about topics that included social justice, the Holocaust, yearnings for tradition, and personal remembrances. "Driving Blind" (left), written in Kramer's handwriting, is a testament to the value of life despite despair. "Remembrance" (below), signed by Kramer, is a testament to his mother. (Both, LK, NPL.)

REMEMBRANCE

When I was twelve,

my mother said to me:

"Run! it is morning.

Run, and don't let me see you

 again

until you can bring back

one strange flower,

or butterfly,

or at least a bird-call!"

Aaron Kramer

Phillip Kleinberg of Northport, an ardent admirer of Aaron Kramer's work, developed a friendship with the poet and collected Kramer's writings and memorabilia. In 2000, this collection, containing chapbooks, original poems, sound recordings, and publications, was donated to the Northport–East Northport Public Library. "Snowsong," signed by Kramer, is in this collection, as are the poems on the opposite page. (LK, NPL.)

SNOWSONG

When a snow is falling
and the night is white, ✓
for a crystal moment
even I am whirling
on the backs of whirlwinds
past the rotted rooftops
where the doves take fright
--for a moment soaring,
for a moment plunging,
for a moment melting
in the white of night. ✓

Aaron Kramer

FARMINGDALE JEWISH CENTER

IVanhoe 6-2500

I. J. MORRIS, INC.

FUNERAL DIRECTORS

Serving Members of
All Societies, Lodges and Organizations

HOWARD P. KOTKIN, Director

46 GREENWICH STREET HEMPSTEAD, N. Y.

I.J. Morris began as a Jewish funeral home in Brooklyn in 1928, the first modern facility. In 1953, the first Jewish funeral chapel was opened in Nassau County. Hempstead was home to a growing suburban Jewish population, as reflected in this advertisement from a Farmingdale Jewish Center journal. In 1977, the business was expanded to an additional location in Dix Hills in Suffolk County. (GM.)

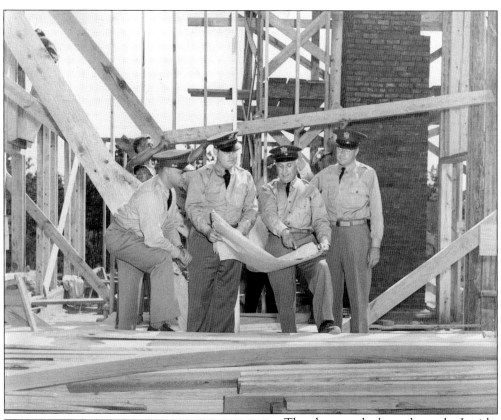

1943

October 14,

SUBJECT: Transfer, Discharge from United States Army

TO : State Director of Selective Service

1. You are hereby notified that_____
_____ was on _____ 1943 transferred discharged
32401943SN) October 14,
from the United States Army by reason of_____
at Fort Slocum, New York.

2. Above named soldier was inducted into the service
through Local Board No. _____ on _____ 19.
702, Suffolk, N.Y. July 8, 42

3. The address given at time of transfer discharge
induction was_____
145 N. Main St., Patchogue, N.Y.

For the Commanding Officer:

R.H. SECUNDA
MAJG USA
ASST ADJ USA

The photograph above shows the Jewish chaplain pointing to the blueprint during the building of the base chapel in March 1942, when Camp Upton in Yaphank was reactivated for the World War II effort. Camp Upton was built for World War I, deactivated between the wars, and reactivated in 1940. After the war, the camp was used for veteran rehabilitation. In 1947, the property became Brookhaven National Laboratory. (LPL.)

In 1943, Arthur Simon, who was a corporal in the US Army, was transferred to Fort Slocum. His address at the time was given as 145 North Main Street, Patchogue. Born in 1903 in Patchogue, Arthur was the oldest child of Meyer and Sarah Simon. The 1910 census indicates that he was born into a Yiddish-speaking household. (HH.)

HELLO-
JUST GOT BACK
AM FEELING GREAT
WILL WRITE SOON AGAIN

COPYRIGHT 1919

Compliments of Jewish Welfare Board, United States Army & Navy

Toward the end of World War I, the Jewish Welfare Board issued a series of postcards to soldiers and sailors to let their families know they were safe and on the way home. The copyright on the front (above) and postmark on the reverse (below) indicate that this postcard was issued in 1919 at Camp Upton in Yaphank. The handwritten note verifies that all is well and the soldier is on the way home. Another series of Jewish Welfare Board postcards of the same era are those issued on troop ships with the image of the ship on which the soldier was traveling. (LPL.)

Rabbi Charles S. Freedman served as a US Army chaplain in the South and in the Pacific theater during World War II. During his rabbinical studies at the Jewish Institute of Religion, Freedman was a student of Rabbi Stephen S. Wise, a leader in the Reform movement. After the war, Freedman served as Hillel director and senior chaplain at Boston University. From 1954 to 1956, he served as rabbi at Sinai Reform Temple in Bay Shore. From 1959 to 1964, he was spiritual leader at Temple Beth Avodah in Westbury. The photograph below shows his grave in the national cemetery at Farmingdale. (Both, JK.)

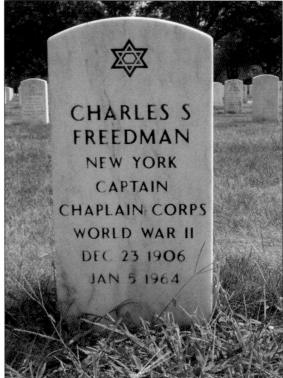

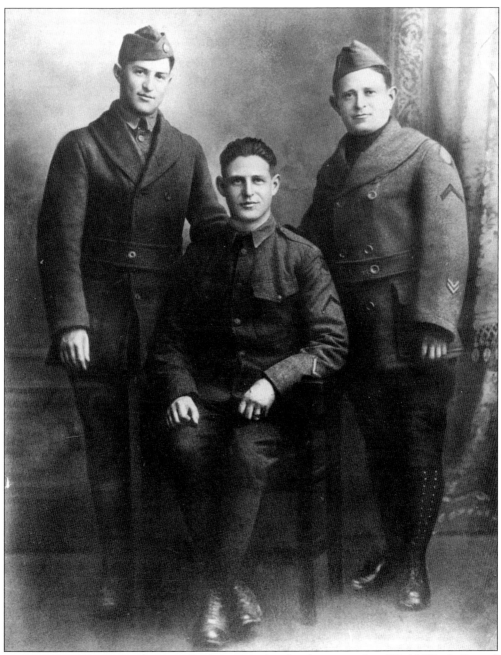

In uniform for this 1918 photograph, three Davidow brothers served in World War I. Samuel Davidow, left, was born in Patchogue in 1899 and remained stationed in the states. Louis B. Davidow, center, was born in Svenigorodka, Russia, in 1891 and served in the trenches of France. Edward Davidow, right, was also born in Russia in 1884 and was a flier with the American Expeditionary Forces. They returned home to enjoy successful careers. (HH.)

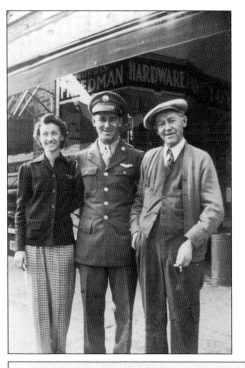

The 1940 federal census indicates that Morris Freedman's children Albert, Henrietta, and Leon worked in the hardware business with their father. Albert and Leon enlisted in World War II. After the war, the store continued to expand so that by 1951, the business sold general hardware and housewares in addition to bicycles. In 1943, Leon Freedman (in the Army Air Corps uniform) poses in front of the business owned by his parents, Jennie and Morris. His sister Henrietta stands to his left and their father, Morris, to his right. Returning to active duty, Leon was killed in action during a bombing raid off the coast of Germany when his plane was hit by enemy fire. The Jewish Veterans Bay Shore Post was renamed the Leon Freedman Post in his memory. (Both, BSHS.)

BAY SHORE SENTINEL and JOURNAL, BAY SHORE, MAY 12, 1955

Jewish War Vets Post Named After Leon Freedman, World War II Hero

Pay Tribute to Bay Shore Man Killed in Bombing Raid Off Germany Coast

The Jewish War Veterans of Bay Shore, at an organization meeting, decided to name the post after S./Sgt. Leon Freedman, Bay Shore airman, who was killed in action off the coast of Germany during World War 2.

The newly-formed veterans' unit has applied for charter as the Staff Sgt. Leon Freedman Post, Jewish War Veterans, of Bay Shore. Temporary officers selected are David W. Siben, commander; Robert Snyder, Frank Spiegelman, vice commanders; Jack Brill, quartermaster; and Arthur Proner, judge advocate.

Permanent officers will be selected at a meeting of the Post on May 23 at the Bay Shore Jewish Centre, Bay Shore.

Sgt. Freedman was the son of Mrs. Freedman and the late Morris Freedman. He was killed in action on April 11, 1944 when his plane

Memory Honored

The Late Leon Freedman

was hit by enemy fire 45 miles off the coast of Germany.

Sgt. Freedman was born in Bay Shore on Jan. 23, 1914. He was grad-

Election of Officers Is Scheduled to Be Held May 23 at Jewish Centre

uated from Bay Shore High School in 1932 and started to work in his father's business, Freedman's Hardware. He enlisted Oct. 13, 1942 in the Army Air Corps. At first he trained as a ground crew mechanic afterwards becoming armorer and gunner on a flying fortress. He was shipped overseas early in 1943 and was stationed in England.

As a tail gunner, Sgt. Freedman made many missions over Germany. He was returning on his eleventh mission from a bombing raid on Posnan, Poland, when his bomber was struck by anti-aircraft fire. The fortress was seen to burst into flames. None of the crew has ever been heard from.

Sgt. Freedman's mother still resides in Bay Shore as does his brother, Albert. His sister, Henrietta, is married to M/Sgt. C. O. Phillabaum and now resides in Brooklyn.

In 1943, Tess Pierce, right, photographed by Chase-Statler, was a groundbreaking woman who enlisted in the Marines to fill positions vacated by servicemen on active duty. Stationed in Washington, DC, her primary assignment was as a teletype operator, but she was also expected to make coffee and empty ashtrays of her male peers, reflective of cultural attitudes of the time. After World War II, Tess married Morris Garber (below). After participating in seven battles in the North Africa theater, Morris was hit by gunfire in the leg. At age 22, he became an amputee who overcame much of the limitation of that circumstance. His hope of becoming a cantor was not fulfilled, due to his inability to stand for long periods. However, with improved prostheses over the years, he was able to work in substitute cantorial positions later in life. (Both, TPG.)

AUTHENTICATE

Last Name (Caps)	First	Middle	Rank	Serial #	Age
FRIEDBERG	William	M.	1st Lt.	O-712787	23

Next of Kin J. Friedberg Relation: Mother

Mr. Kalman Friedberg Father

150 N. Main Street N.Y.,N.Y. Vote Credit

Source of Information: worker 4/10/46 in Sayville,N.Y. same
Casualty blank sent in by worker 4/10/45 without L
inq. in Friedberg fldr. P

Branch of Service	Action Area	Honor Roll Date
Air Force	Italy	

Worker Consulted ✱ P S cheff Family

Inquiry Date

None

$ nvk Follow-Up Dates 2/29/46

William Freidberg, son of Kalman and Pauline, served with the rank of first lieutenant during World War II. He was taken prisoner and then liberated. After the war, Friedberg continued in his father's hay and grain poultry supply business, which expanded into Friedberg's Farm and Garden Supply. The business ultimately became a bicycle shop. In the 1960s, Friedberg sang in the Sayville Musical Workshop. (Ancestry.com. US, WWII Jewish Servicemen Cards, 1942–1947.)

NC BS
PH

authenticated

AWARD PRES. CIT.

NAME SCHECTER Irving RANK Maj. AGE 27
 LAST (CAPS) FIRST MIDDLE

NEXT OF KIN Mr. & Mrs. Jerome Schecter RELATIONSHIP Parents

ADDRESS ? CITY Smithtown Branch STATE N.Y.

SOURCE OF INFORMATION Casualty blank sent in by worker 2/12/45
 in Schecter folder

INQUIRY DATE none FOLLOW-UP DATES

WORKER CONSULTED FAMILY

DATE APPEARED IN HONOR ROLL BRANCH OF SERVICE Marines

mb

Irving "Buck" Schechter served as commander of Company A 24th Marines, eventually achieving the rank of major. Wounded during the war, he later had a successful career as a lawyer. He served as Smithtown town attorney and was the president of the Bank of Smithtown. Schechter, who died in 1992, is buried in the cemetery of the Kings Park Jewish Center. (Ancestry.com. US, WWII Jewish Servicemen Cards, 1942–1947.)

Mitchel Air Force Base, known as Mitchel Field, was established in 1918 and decommissioned in 1961. Arthur Szyk, a prominent artist and political cartoonist, widely promoted anti-Nazi and anti-totalitarian ideals. In July 1942, a USO-sponsored exhibit of 30 pieces of Szyk's art was held at Mitchel Field. After this exhibit, the base commander dubbed Szyk a "soldier citizen of the free world." At right, "December 7, 1941" was produced in the immediate aftermath of Pearl Harbor. This biting image depicts Hirohito's attack on the United States while Hitler and Mussolini look on in admiration. "And They Call That Doolittle" (below) is a satirical illustration of Hirohito following the air raid on Tokyo in April 1942 commanded by Col. Jimmy Doolittle from the deck of the USS *Hornet*. The Doolittle Raid was in retaliation for the Pearl Harbor attack. (Both, reproduced with the cooperation of The Arthur Szyk Society, Burlingame, CA: www.szyk.org.)

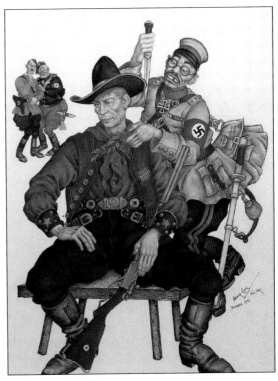

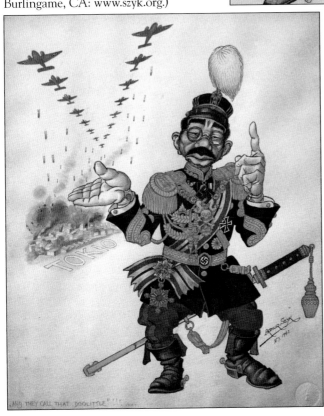

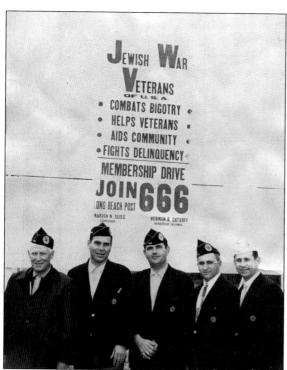

The Jewish War Veterans Post 666 in Long Beach created an important poster as part of their membership drive. While it boasts general community improvement, it is important to note that the first item proclaims fighting bigotry. The implication is that there existed an anti-Semitic climate in Long Beach in the 1960s. This post still exists. (LBHPS.)

Maurice Gutman, W2VL, pictured in his Oceanside home around 1952, was a volunteer with the Military Affiliate Radio System (MARS). That worldwide system includes groups and individual licensed amateur radio operators who assist in emergency communications. In World War II, Major Gutman, of the Army Air Corps, was awarded the Bronze Star for setting up an air-sea rescue radio network in the Mediterranean that contributed to rescuing 235 airmen. (FG.)

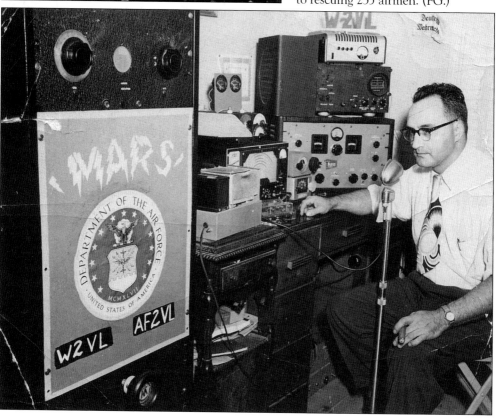

William Levitt is pictured in 1962 presenting an award plaque at a ceremony of the Jewish War Veterans at Island Trees High School. Levittown Post No. 640 Jewish War Veterans of the United States Memorial Hall Association was registered in early 1955. The company continues to be active. (LPLHC.)

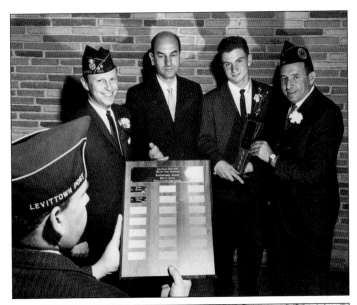

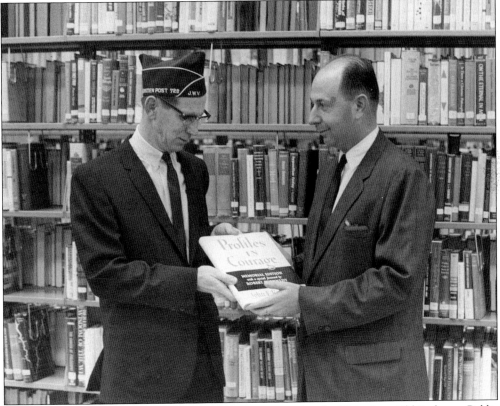

In November 1966, Jewish War Veterans Post 728 presented to the Plainview–Old Bethpage Public Library a large-type memorial edition of *Profiles in Courage* by John F. Kennedy. The presentation is being made to library director Joseph Eisner by Comdr. Eugene Goidell. Since 1954, Goidell and his family were residents of Plainview, where both he and his wife, Anna, were active in community life. (POBPC.)

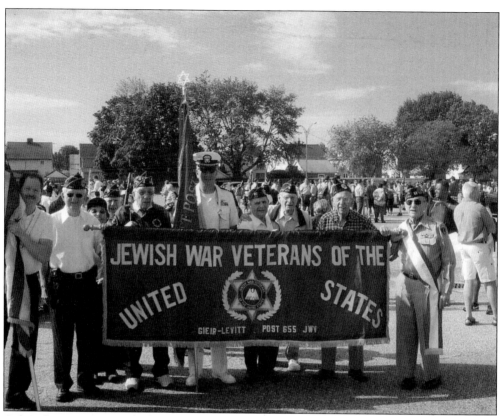

Col. Jack R. Hayne, a West Point graduate, is currently commander of the Jewish War Veterans Gieir-Levitt Post 655, which recently celebrated its 55th anniversary at the North Shore Synagogue. Post 655 participates in the annual Hicksville Memorial Day parade. In May 2014, Hayne (far right) was the grand marshal for that parade. (JH.)

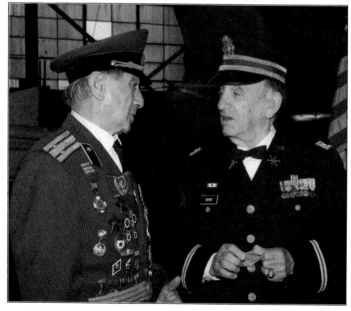

During the 1962 Cuban Missile Crisis, American colonel Jack Hayne (right) and Soviet colonel Vladimir Edelman were counterparts who met in a hangar at Republic Airport in Farmingdale as the world waited to see what would happen. At that time, Hayne was teaching NATO officers about guided missiles. This photograph was taken at the American Airpower Museum at Republic Airport during a 2012 meeting on the 50th anniversary of the crisis. (Photograph by Pearl Hayne; JH.)

Four

EXPANDING JEWISH LIFE DESPITE PREJUDICE

The wide presence of synagogues and Jewish-based organizations did not preclude Jews from integrating into the wider experience available on Long Island. Jewish families enjoyed the recreation and business opportunities Long Island offered and, for the most part, enjoyed these pleasures with friends, neighbors, and colleagues.

History, however, did play a role that was specifically threatening to the Jews of Long Island. During the 1920s and 1930s, the Ku Klux Klan had a vast local presence. While Jews were not their only targets, Klan members were highly integrated into the political, educational, and commercial venues of the region. They were a presence to be reckoned with, not only for the violent acts they committed but also for the pressure they exerted on the systems that are supposed to protect citizenship. In the same period, the Cold Spring Harbor Laboratory became the world center for eugenics research. Their findings actively supported Hitler's race theory. Camp Upton in Brookhaven, which was an active military base during World War I, lay fallow after the Treaty of Versailles. In the mid-1930s, that property was utilized to house Camp Siegfried, a German American recreational area that proselytized Nazi ideology. When Germany invaded Poland, that venue was shut down and the property recommissioned as Camp Upton to support the growing war effort. Social discrimination also played a role against Jews. Jewish doctors were not allowed privileges at some hospitals, country and golf clubs had exclusionary values toward their membership, and children were subjected to anti-Semitic slurs in school.

Despite these negative forces, Jews thrived on Long Island. The response was the same as it was elsewhere where Jews established their own organizations. Long Island Jewish Hospital in New Hyde Park was the response to prejudice against Jewish doctors. Jewish day schools were formed. Country clubs were created. Ironically, it was the presence of such institutions that inspired the flourishing of the Jewish community.

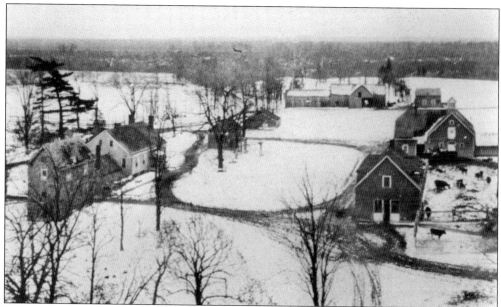

From 1905 to 1907, the Jewish Agricultural and Industrial Society acquired land in Kings Park to be used as a test farm. This project was created in conjunction with the Baron de Hirsch Fund, whose mission was to help Jews develop trade skills that would lead to employment and social acceptance. The test farm was not a successful venture, and by 1907 the property pictured above was sold to the Howard Colored Orphanage. The Chanin family is pictured below around 1907. From left to right are (first row) Eva and Mordechi; (second row) Esther, Aaron, Hirschel, and Moishe; (third row) Rise, Sara, Isrol, and Jacob. Eva was born 1905 in Kings Park. The family lived on the test farm and later relocated to a successful farm in Flemington, New Jersey. When Moishe died, the family took in boarders until 1917, when the farm was sold at auction. (Above, KPHM; below, DC.)

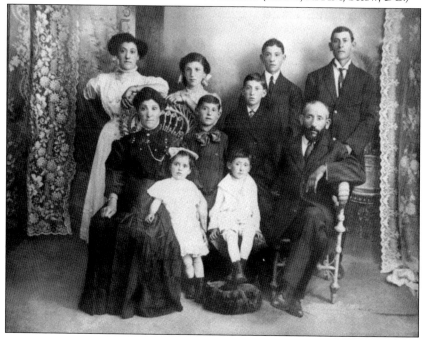

The Baron de Hirsch Fund had a mission to encourage Jews to engage in agriculture and industrial trades. To support this goal, scholarships were provided to young Jewish men to attend the State Institute of Applied Agriculture, now Farmingdale State College. Harold Meadoff, seated at bottom right, a scholarship recipient, is shown in this 1931 photograph as a member of the Theta Gamma Fraternity. Meadoff's application indicates that he wished to explore aspects of agriculture but was unsure what would be of interest. Most recipients were from New York City, but Nathan Levenson, Morris Weinberg, Eli Scheinman, and Paul Jacoby were from the Long Island communities of Cedarhurst, Huntington, and Kings Park. (Both, FSC.)

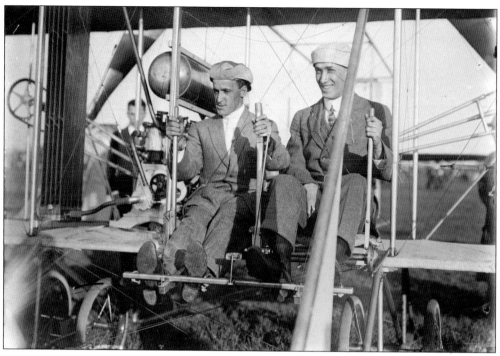

The history of aviation is part of Long Island history. Arthur L. Welsh, the first Jewish American aviator, established flying schools for the Wright Company. Here, Welsh (left) is training William Beatty at the Wright Flying School on Long Island in 1911. Welsh's Orthodox funeral in 1912 was attended by Orville Wright. In 1941, B'rith Trumpeldor opened the Jewish Aviation School to support the national defense effort. (LOCPPD.)

Columbia Aircraft of Valley Stream was founded in 1927 at Curtiss Airfield by Charles A. Levine. Closed during the Depression, the company was revitalized during World War II. Isadore "Izzy" Rabinowitz (pictured) was a test pilot for Columbia Aircraft during that time. The site is commemorated by a historical marker. (CAM.)

Charles A. Levine is seen at right standing on the right. Levine's flight from Mitchel Field one month after Charles Lindbergh's famous flight across the Atlantic was longer and faster. As the first Jewish aviator to achieve international fame, and as the first trans-Atlantic passenger, he was highly feted. He counterclaimed anti-Semitic prejudice during the height of the eugenics movement. A song composed in Yiddish and English, "Levine! with his Flying Machine," extolled his story as a demonstration of pride in his Jewish heritage. At one point, he was arrested for an attempt to smuggle a refugee from a Nazi concentration camp into the United States (Both, CAM.)

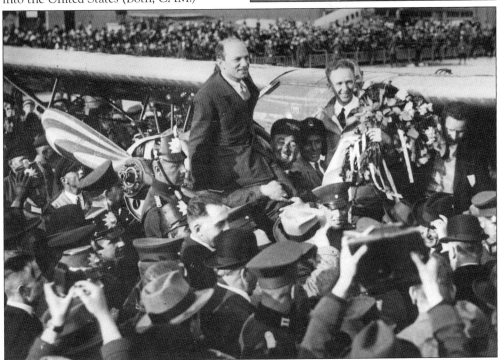

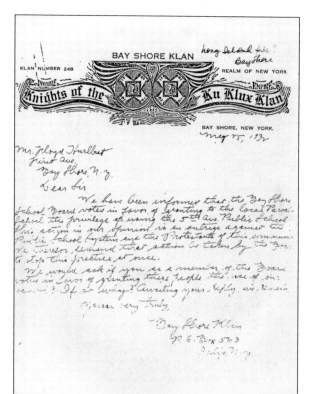

The Ku Klux Klan was extensively integrated into Long Island society. One example lies in the document shown. In this 1935 letter to Floyd Hurlburt, superintendent of Bay Shore Schools, the local KKK post protested allowing the local parochial school to use public school facilities. The outcome of this request is unknown. (BSHS.)

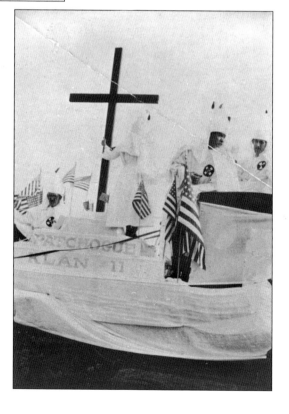

Patchogue was a strong center of KKK activity and a perfect location for this c. 1925 parade. The elaborate float, pictured as it passed Waverly Avenue north of the cemetery, is a testament to the Klan's unabashed might and influence. In 1924, Patchogue was the scene of a mass rally in which KKK ideology was promulgated. (Photograph by Alvin R.L. Smith; LPL.)

The Lindenhurst KKK float, pictured at right in the 1928 Patchogue parade, represents a stronghold in KKK power. The Huntington float below shows even the horses in full KKK regalia as parade watchers, dressed in their finest, look on. News reporters were often invited to such events to the extent that they were picked up at the local Long Island Rail Road station and transported to the event. On the night of October 12, 1923, Lindenhurst, Huntington, and at least four other nearby towns were the location of a dozen cross burnings. (Both photographs by Alvin R.L. Smith, LPL.)

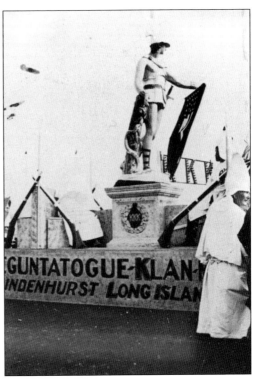

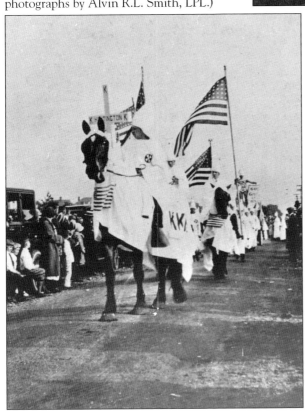

The Carnegie Institution of Washington Station for Experimental Evolution was established in 1904 in Cold Spring Harbor, under the direction of Charles Davenport. Using the credible scientific belief of the time, this laboratory became the center of the eugenics movement. The theory behind this evolution-inspired movement is that physical traits are a definition of racial ranking into superior and inferior races. One component of Nazi theory was the supposed superiority of the Aryan race. Using the findings of eugenics research, touted as scientific "proof," Nazis justified their belief in the inferiority of the Jewish race. Initially, the Eugenics Record Office was located in Stewart House, pictured above. Below, a field research training class is conducted in a tranquil outdoor setting. (Both, CSHLA.)

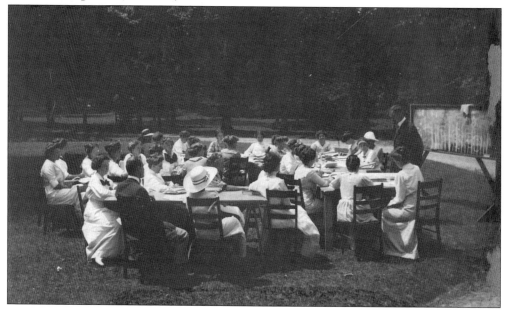

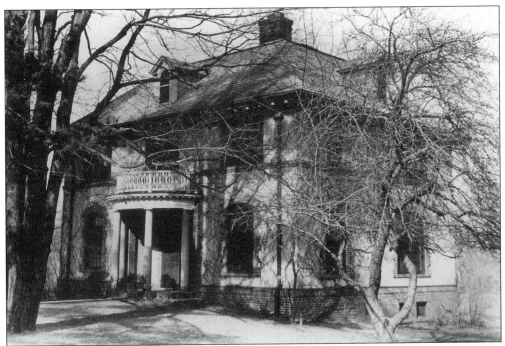

The Eugenics Record Office building is pictured here in 1935, one year after Charles Davenport's retirement. In 1939, the Eugenics Record Office was closed. The records were eventually dispersed between three institutions: the American Philosophical Society, Jackson Laboratories, and the Genealogical Society of Utah. An online archive is maintained. (CSHLA.)

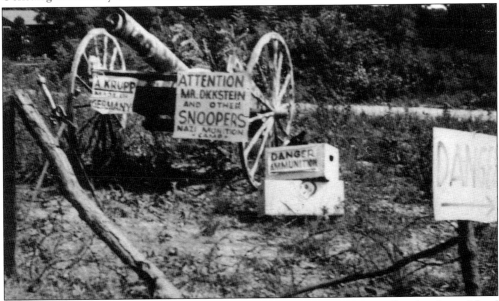

Camp Siegfried, located in Yaphank, was a camp of the German American Bund on Long Island and visited by members in the New York City area. The camp was established in 1935 and shut down in 1939 by the American government when Germany invaded Poland. Jewish congressman Samuel Dickstein led opposition to this Nazi compound in his investigation of un-American activities. (LPL.)

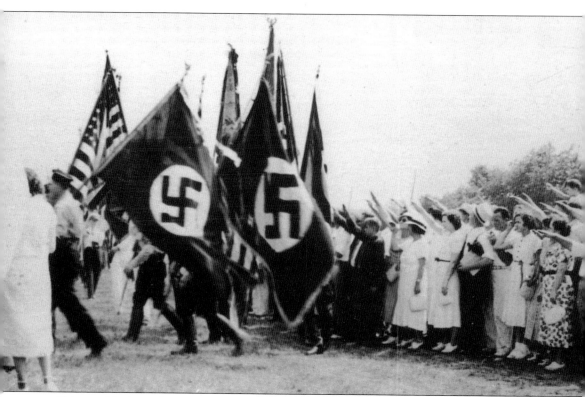

Elaborate Nazi parades were commonly held at Camp Siegfried. Parade watchers raise their arms in the *heil* salute as the Nazi and American flags pass. Lindenhurst, formerly known as Breslau, was originally a mid-19th-century German settlement that attracted German Jews to the area. Later, the German population attracted a large controversial Bund presence. Most notable was a 1937 Phingfest Nazi parade in Lindenhurst. (LPL.)

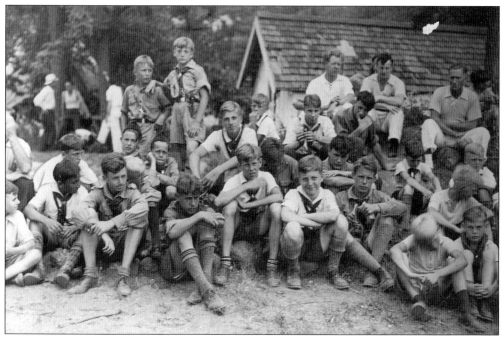

Camp Siegfried was created to be a recreation area for the German American Bund. In this 1937 photograph, there is a uniformed group of boys from New York City at the youth camp. The boy in the top row, second from left, is displaying a knife in his belt. (Photograph by *Chicago Times*, LPL.)

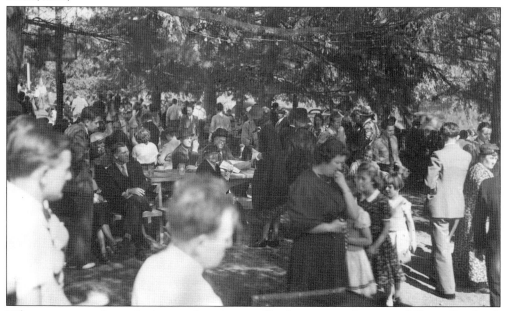

What appears to be a picnic anywhere is actually the opening festivity of Camp Siegfried, which was delayed due to threatening weather conditions. Camp attendance was supported by a special Sunday train run by the Long Island Rail Road. There were charges against the German American Bund by Suffolk County on the grounds that they had failed to register as an oath-binding organization. (Photograph by Acme, LPL.)

The Kings Park Jewish Center was housed in its original building on Patiky Street, which had been expanded with the influx of Jews after World War II. Tragedy struck with a 1962 fire that completely destroyed the building. Adding to the devastation, a rescued Holocaust Torah was also incinerated. In this iconic photograph, a fireman is rescuing books from the destruction. (KPHM.)

Kings Park Jewish Center

ROUTE 25A -- (EAST MAIN STREET)
KINGS PARK, L. I., NEW YORK 11754

NORMAN ZDANOWITZ, RABBI
HOME TELEPHONE: AREA CODE 516
269-4045

June 21, 1971

OFFICE TELEPHONE: AREA CODE 516
269-1133

Dear Member:

 Our CEMETERY has been desecrated! Sometime between Wednesday and Friday of this past week, hooligans invaded our cemetery, turned over 29 headstones, smashing some of them and destroying all of the cement grave borders on those graves where headstones were overturned.

 It is urgent that you attend the Congregation meeting on Wednesday, June 23 1971, at 8:30 P.M., when this matter must be dealt with.

Hoping to see you at the meeting, I am

Very Truly yours,

Stuart Wadler

Stuart Wadler, President

There was more destruction in 1971, but this time it was in the form of desecration in the cemetery of the Kings Park Jewish Center. This letter is a call to action, a meeting of the congregation to discuss the consequences of this vandalism. Anti-Semitism had begun to show again, as the Jewish community of Kings Park was reaching its peak post–World War II growth. (SCUASBUL.)

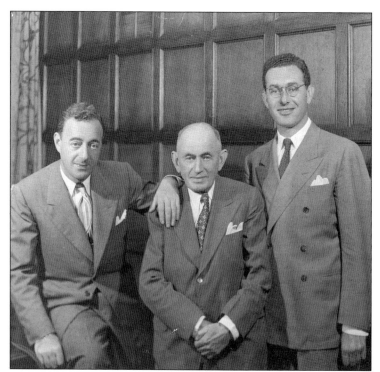

The Levitt family were the developers of Levittown, the first modern planned suburban community that was built in an assembly-line manner. Abraham Levitt (center) and his sons William (left) and Alfred (right) were the master builders of this community. Beyond home construction, the community contained nine swimming pools, a community center, and seven village greens. (Photograph by Cole Portraits, LPLHC.)

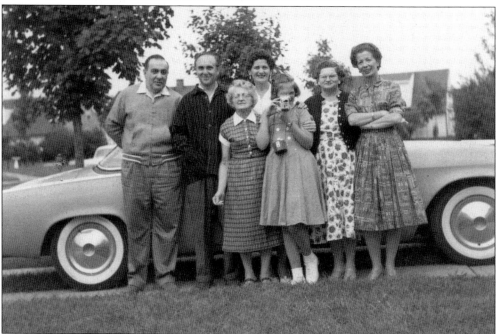

Three generations of the extended Goldschmidt family stand in the driveway at 11 Satellite Lane in Levittown. Proudly posing in front of Joseph's new Studebaker are, from left to right, Karl Goldsmith (visiting from the Bronx), Joseph Goldschmidt, Grandma Hedwig Allweiss (Isabella's mother), Isabella Goldschmidt, Monica Goldschmidt, Sophie Goldsmith, and Tilly Goldman (visiting from New Jersey). (LG.)

Carl and Gertrude Solomon were among the earliest residents of Levittown. At 35 Rainbow Lane, they raised their two children, Barbara and Paul. Their suburban dream was a very different world from that of the extended family they left behind in Brooklyn. Their nephew Jay Miller, who lived in Brooklyn, was a frequent visitor to their Levittown home, where he was able to enjoy aspects of a suburban childhood that could not be achieved on the streets of Brooklyn. Riding a bike down the middle of a street of newly constructed Cape Cod homes, around 1951, was an expression of that freedom. In addition to homes, Levitt built swimming pools. Below, Jay is seen taking a dive into the pool at the South Village Green. (Both, RM.)

Pictured is young 1940s patriot Morris Hodkin, grandson of a founder of the Patchogue Jewish Center. Long Island Jews were involved in their communities. They ran for various political offices, joined social organizations, and participated in community events. Jewish patriotism was very strong during World War II. (MH.)

Prior to moving to Long Beach, their first Long Island residence, Tess and Morris Garber have a "lazy bones" day at a Long Island park while visiting Tess's brother Manuel Pierce in 1946. Reflected in this photograph is the essence of the suburban dream of a young couple just prior to the birth of their first child, whose name was to be Cheryl. (TPG.)

After World War II, veterans were offered the opportunity to receive low-interest mortgages on home purchases. In 1952, Tess and Morris Garber, both veterans, purchased their first home in Hempstead. Pride in their new home is exhibited by the "G" monogram on the screen door. Morris Garber sits on the stoop with his children Cheryl and Gary. (TPG.)

Gloria Chauser Bernstein is relaxing in her new home in 1948 in Hempstead, engaging in one of her favorite pursuits—reading. She had told her husband-to-be, Ben Bernstein, when she was being courted during the war that "I am a cheap date. All I need to keep me happy are books and records." She had been a music major in college during the 1930s. (WB.)

BOARD OF ELECTIONS
COUNTY OF NASSAU
STATE OF NEW YORK — UNITED STATES OF AMERICA

WE CERTIFY THAT *Gloria Bernstein*

OF *2 Beaufort Lane East*

REGISTERED THIS *6th* DAY OF *October* 19*60*

IN *153* E.D. *4* A.D. BY *Lillian Rothhof*

910 413
REGISTRATION NUMBER OF VOTER

WILLIAM D. MEISSER
LAWRENCE W. McKEOWN
COMMISSIONERS OF ELECTIONS

The 1960 Board of Elections registration card for Gloria Bernstein confirms her self-description: "politics is my passion." She was an active Democratic committee person and worked with the League of Women Voters. She campaigned avidly for Adlai Stevenson for president in 1952, 1956, and 1960. She continued to remain active in politics for the remainder of her life and loved to debate the issues. (WB.)

In order to support his new suburban lifestyle, Ben Bernstein commuted on the Long Island Rail Road from his home in Hempstead to his job as a salesperson in Manhattan. Shown are the front and back of his monthly commuter pass. Between the late 1940s and mid-1950s, Ben Bernstein discovered that it was very difficult to raise a growing family in the new Long Island suburbs on a salesman's salary of $125 per week. With the help of a close friend, in 1956 he established a home decorating business, Wilberne Interiors. That business became his family's key to the American and Long Island dream. (Both, WB.)

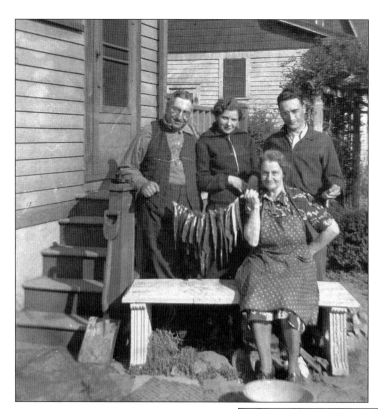

Pictured from left to right are Irwin, Dorothy, Estelle (seated) and Maurice Gutman. The Gutman family moved to Devon Street in Lynbrook in the 1920s. Maurice Gutman and Dorothy Konheim were both members of the Young Folks League of Temple Emanuel of Lynbrook. They were married in 1937. This photograph was taken alongside their home in 1938 or 1939. They all enjoyed fishing. (FG.)

By 1950, the Patchogue Jewish community was established and secure enough that a charter was granted for the Boy Scouts of America to open a troop at the Patchogue Jewish Center. Such an action was critical, as it represented integration and acceptance to the community at large by a nonsectarian organization. (TBP.)

Delicatessen and appetizing stores were favorite places for Jews and others to buy salted and smoked foods, which are synonymous with Jewish culture and Jewish food. An example is Max's Appetizing and Kosher Delicatessen in Hewlett. From left to right are current owner Robert Leshansky holding his son Jeff, Joe Leshansky, and Jerry Leshansky, who founded the business in 1947. (RL.)

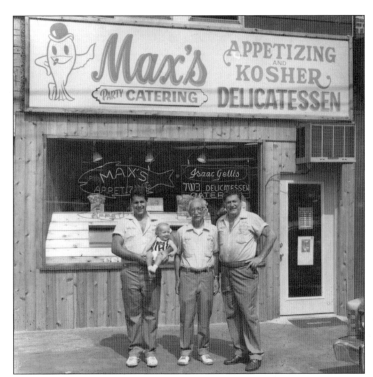

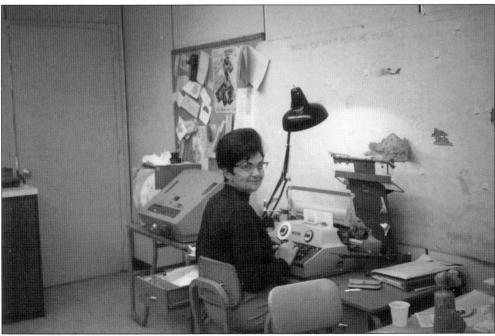

The United Nations was located in Lake Success from 1946 to 1951, while the Manhattan building was under construction. Tess Garber was employed there using her skill with a Verityper machine. The Verityper was a machine version of what is now word processing and publishing software. The skills she learned there led to her employment at the Nassau Library System from 1958 to 1988, initially in public relations and then in reference. (TPG.)

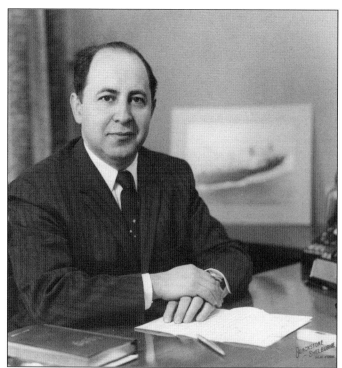

Samuel H. Wang (1916–1976), shipping company owner, philanthropist, and Zionist, settled in Great Neck with his wife, Gloria, and their children in 1955. Wang escaped to the United States as a Holocaust refugee in 1940. In 1957, his ship SS *Kern Hills* broke the Egyptian blockade of Israel-bound ships and delivered oil to the Eilat pipeline. Wang was an outspoken supporter of Israel and an active member of many Jewish organizations. (Photograph by Blackstone-Shelburne, DW.)

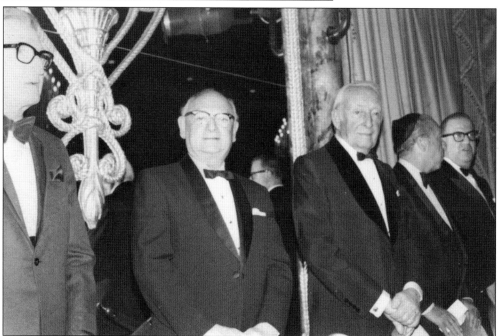

Prominent real estate owner Max L. Koeppel; his wife, Minnie; and their children moved to Great Neck in the late 1940s. Koeppel was a philanthropist who supported the Brooklyn Hospital and Brooklyn Philharmonic, was vice chairman of the Union of American Hebrew Organizations, and served as vice president of the New York Federation of Reform Synagogues. In this photograph, Koeppel (left center) is honored with Abba Eban (far right). (AGK.)

When Weight Watchers was incorporated in 1963, it enjoyed immediate popularity. Innovative entrepreneur Rhoda Rubin bought the Suffolk County franchise in 1965. Shortly after, storefront centers were strategically located throughout Suffolk County. Rubin owned Weight Watchers of Suffolk County until 2006, when it was acquired by Weight Watchers International. The Rubin family now owns the Baiting Hollow Farm Vineyard and horse rescue. (RM.)

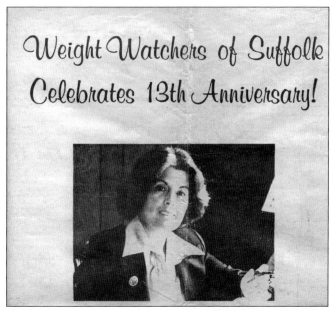

Weight Watchers of Suffolk Celebrates 13th Anniversary!

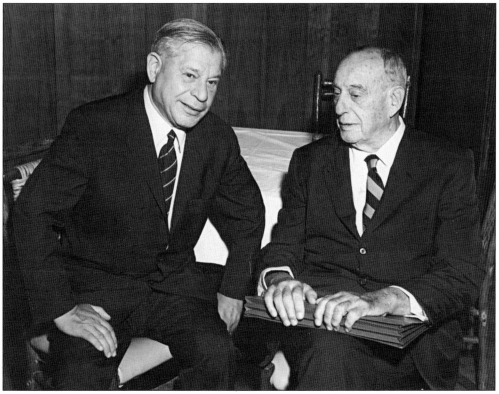

Robert Moses (right), known as the "master builder of New York State," confers with Sidney Shapiro. The Belmont Estate in North Babylon housed the Long Island State Parks Commission, which worked closely with Robert Moses to develop projects such as Jones Beach, Ocean Parkway along the barrier beaches of Nassau and Suffolk Counties, the Atlantic Beach Bridge, and a multitude of other projects. (VBHPS.)

Jack Hayne served as an officer in combat during the Korean War from August 1950 to March 1952. He was then trained in guided missiles and was the guided missile staff officer for the 1st US Army Air Defense Command at Fort Totten. Afterwards, Hayne was the project engineer responsible for the trainer design and the integration and testing of all the electronic systems. He worked on the E-2C Integrated Systems Maintenance Trainer. Only two such devices provided by Grumman Aerospace exist in the Navy inventory. Above, Hayne's wife, Pearl Anderman, is in the cockpit in the copilot's position. (Both, JH.)

Five

Enjoying a Jewish Summer Community

With over 100 miles of oceanfront shoreline to the south and another 100 miles of Long Island Sound shoreline to the north, Long Island is a summer paradise. Peconic Bay lies between the forks of the eastern end of Suffolk County. Fire Island, a barrier beach along the southern shore, is a summer playground for ordinary families as well as the rich and famous.

There were issues that developed in the early days of Long Island as a summer paradise. When an 1892 ship carrying immigrants was quarantined at the Surf Hotel on Fire Island, there was much opposition. Later, when Robert Moses proposed the continuation of Ocean Parkway from the Fire Island Lighthouse to the west and Montauk to the east, conservationist Maurice Barbash fought the battle and won. Barbash, who was a supporter of the Israel Oceanographic and Limnological Research institution, developed the environmentally friendly community of Dunewood on Fire Island. The conclusion to this philosophical contest is that Fire Island to the east of the lighthouse enjoys a large section of the national seashore, and the remainder has maintained its rustic pristine condition. Herman Wouk was a founder of the Fire Island Synagogue.

Many famous and not-so-famous Jews flocked to Long Island during the summer. Otto Kahn, a wealthy German-Jewish financier, built Oheka Castle as his summer residence in Huntington. Members of the Straus family, of department store fame, also had summer residences on Long Island. Robert Moses, a descendant of German-Jewish immigrants, had a home in Babylon. Albert Einstein vacationed in Southold.

Jewish organizations from New York City financed summer camps and programs on Long Island. One important example is the Usdan Center for the Creative and Performing Arts, which opened in 1968 in collaboration with the Federation of Jewish Philanthropies. Long Island continues to be an important summer recreational region of the New York City metropolitan area.

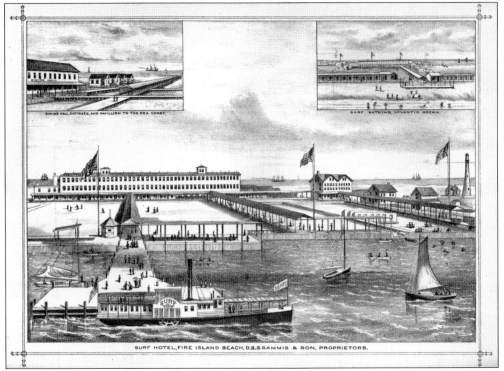

From 1865 to 1892, the Surf Hotel on Fire Island enjoyed popularity as Long Island's first vacation resort. Guests were ferried from the Babylon railroad station across the Great South Bay to Fire Island. By 1892, however, the hotel suffered decline. The SS *Normannia*, bound for New York with largely Jewish immigrant passengers, became a victim of the cholera epidemic. The Surf Hotel was purchased by the State of New York and became a quarantine station. (BTH.)

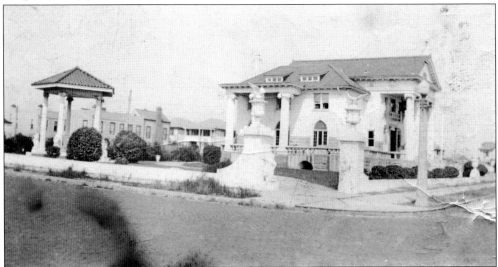

Established in 1923, the Pride of Judea Orphan Home became the residence of 75 infants and toddlers. By the 1930 census, there were 215 male and female residents. As early as 1936, children from the Pride of Judea were bussed to Long Beach in order to spend time in the summer beach environment at the house shown here. (LBHPS.)

Pulitzer Prize–winning author Herman Wouk lived in Great Neck and was a founding member of the Great Neck Synagogue. Wouk also had a summer home in Seaview on Fire Island, where he founded an Orthodox congregation in 1952. Rabbi De Sola Pool, spiritual leader of Congregation Shearith Israel in Manhattan, also summered on Fire Island and lent his support to the effort. (Photograph by Editta Sherman, LRS.)

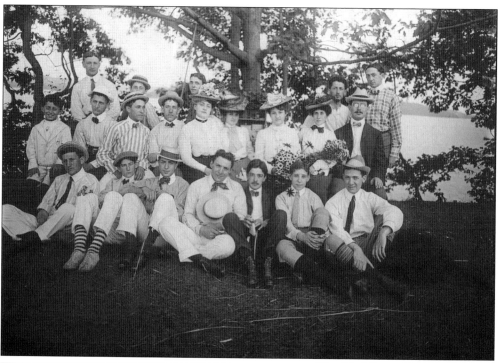

The 92nd Street Young Men's Hebrew Association (commonly known today as the 92nd Street Y), located in Manhattan, operated summer camps on Long Island. In 1903, a summer vacation camp was established in Sayville. From 1904 to 1909, the camp operated in Centerport. Located in a bucolic area along the northern shore of Long Island, Centerport provided the water, woods, and soft rolling hills that would support camping and vacation activities. The H. Raess photograph above shows staff, male and female, dressed in typical attire of the era: straw hats, striped hose, and bow ties. The camp was geared toward teenage boys and young men. The bulletin at left shows the advertisement designed to attract people to attend the camp. (Both, 92Y.)

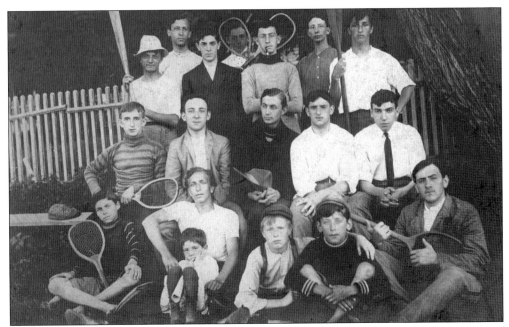

The 92nd Street Young Men's Hebrew Association camp was described in a bulletin as a time of "recreation without temptation." The camp property was 30 acres along Huntington Bay. As can be seen here, the summer camp at Centerport offered tennis, boating, and bathing, among other activities for young men, serving them in groups of 100 at a time. Membership in the association was not required. The camp was conducted in accordance with a Jewish lifestyle, serving kosher meals and requiring adherence to discipline guidelines. Today, the 92nd Street Y continues to operate summer camps for girls and boys of all ages and backgrounds. (Both, 92Y.)

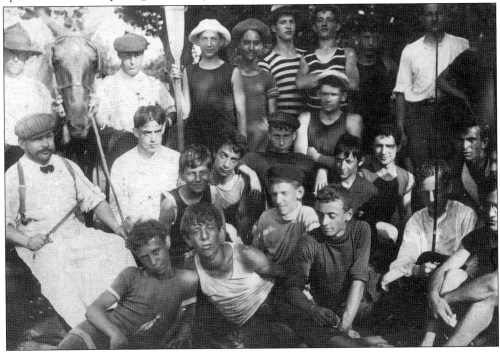

Dora Hodkin was involved in many civic community events. When she was a child attending the Patchogue Hebrew School, Hodkin entertained by singing two songs at a mothers' event in the Supreme Court chamber. Later, she volunteered in social events at Camp Upton just after World War I. Here, Hodkin is participating in a beauty pageant. (MH.)

Albert Einstein enjoyed the summer of 1939 in Southold. In the course of that summer, Einstein walked into the general goods store owned by David Rothman, the first Jew in Southold. They discovered a common interest in music. A lifelong friendship developed that was initiated by the purchase of a pair of sandals. Einstein is shown here in the home of David Rothman during one of their chamber music sessions. (SHS.)

Otto Hermann Kahn (1867–1934) was a German Jewish financier, philanthropist, and board member of the Metropolitan Opera. Kahn built Oheka Castle, below, in 1919 as his summer residence in Huntington. "OHEKA" is an acronym of his full name. Known for his lavish taste and lifestyle, Kahn built the French chateau for an estimated $11 million. Located along Long Island's Gold Coast, this structure was among many of the gilded age where important people were hosted in lavish surroundings. Although Kahn did not put his Jewish identity at the forefront, it was he who bridged the social gap between the Jewish and gentile elite of New York City, particularly as a patron of the arts. (Both, OC.)

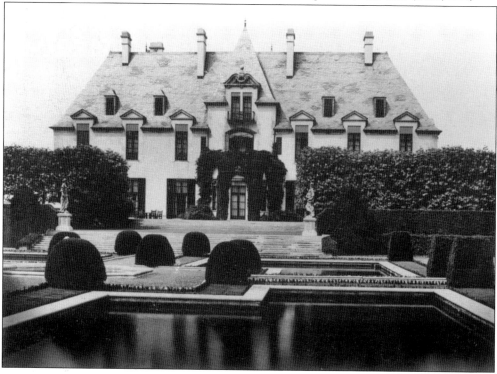

Otto Kahn married Addie Wolff, whose father, Abraham Wolff, was a partner in Kuhn, Loeb & Company. The marriage enabled Kahn to become a partner in this esteemed financial institution. A large painted version of the photographic portrait at right is on display in the Addie Kahn Room at Oheka Castle. Maud was one of the Kahns' four children. The photograph below was taken at the wedding celebration between Maud and Capt./ Bvt. Maj. John Charles Oakes Marriott at Oheka. The ceremony was held in a local church. The couple had one child who did not marry. Oheka Castle is now listed in the National Register of Historic Places and continues to keep Kahn's legacy alive for future generations. (Right, OC; below, VFO.)

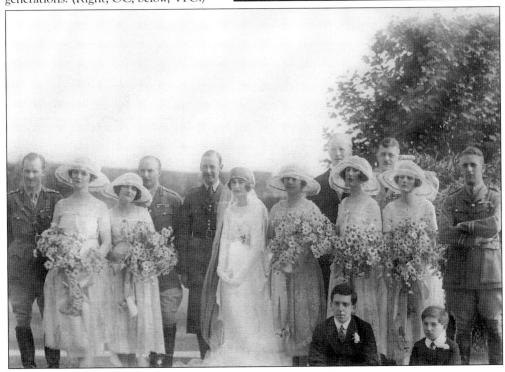

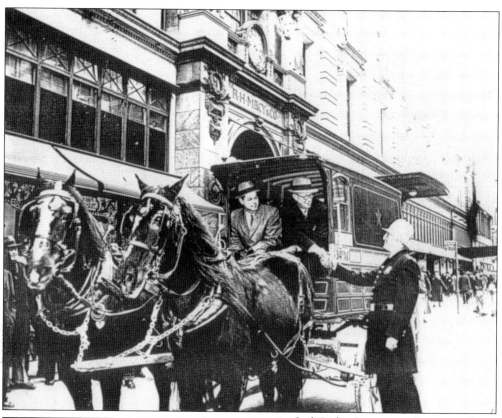

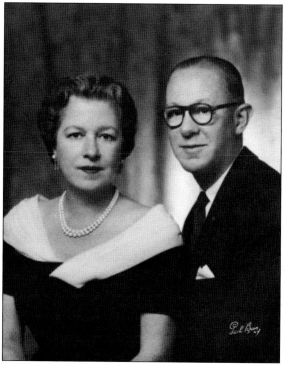

Jack Isidor Straus was the namesake and grandson of Isidor and Ida Straus, who died on the *Titanic*. From the time of his Harvard graduation in 1921, he was employed by Macy's, eventually becoming chairman in 1956. After retirement, he remained chairman of the executive committee until 1976. Straus loved his summer home in Jericho known as "Green Pastures" and during that season did not mind the Long Island Rail Road commute to Manhattan. Straus is pictured above with his son Kenneth sitting in the historic Macy's delivery wagon. At left, Jack is with his wife, Elizabeth Browne. (Above, SHS; left, photograph by Sack Bros.; SHS.)

Edward Kuhn Straus, cousin of Jack Straus and another grandson of Isidor and Ida Straus, was a Navy pilot during World War II. Straus owned a large historic house in Oyster Bay. His favorite room in this house was a chicken coop that he converted into his office. The house was donated to the Society for the Preservation of Long Island Antiquities with the right of tenancy until his death. After his death, the property was sold. (Both, JC.)

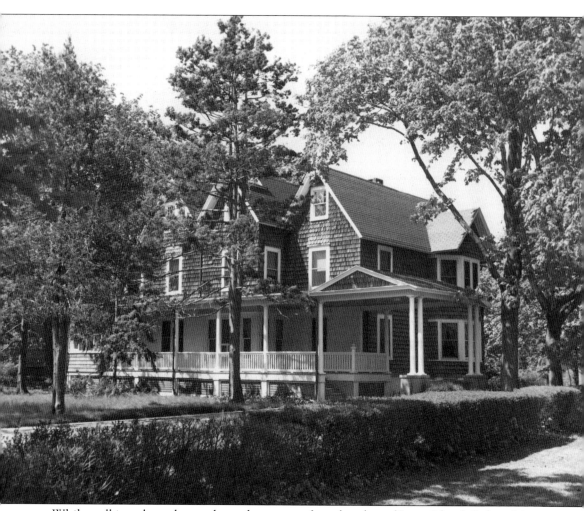

While walking along the southern shore oceanfront beaches of Long Island, Robert Moses acquired his inspiration to develop them. Jones Beach and Ocean Parkway partially represent that vision. Moses owned this house, which was located on Thompson Avenue in Babylon, but was eventually destroyed by a fire. From that vantage point, he not only entertained but further enjoyed and appreciated Long Island for all that it has to offer.

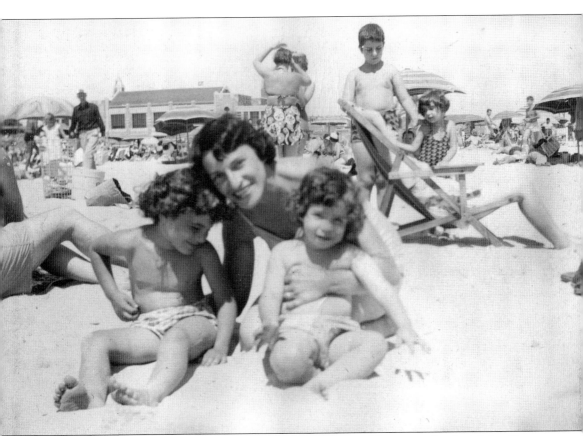

Although the Salowe family resided in Jackson Heights, Queens, like many other Jewish families, they took advantage of the proximity of Jones Beach in Nassau County to enjoy a recreational outing. In the foreground of this 1950 photograph, the author Rhoda Miller is seen with her mother, Sylvia, and sister Pamela. In the background, the bathhouse can be seen as well as the classic striped rental umbrellas. (RM.)

EPILOGUE

The photographs in this book portray the development of the Jewish community on Long Island from humble beginnings to a thriving Jewish religious and social life. In 2015, Congregation Beth Israel in Hempstead is celebrating its 100th anniversary. However, many synagogues are merging in order to maintain viable congregations. Just as the face of the Jewish community changed over the last 100 years, so it continues to evolve. The massive post–World War II population growth has given way to Long Island's changing demographics due to intermarriage and economics. An increasing number of people describe themselves as Jewish but are unaffiliated with a synagogue. Many synagogue websites describe themselves as "inclusive" and "egalitarian" to attract interfaith and nontraditional families. As baby boomers retire, many are leaving Long Island for warmer climates, lower taxes, or to follow children living elsewhere.

Despite these factors, there is a new and vibrant Jewish community. Many Israelis—and Jews of Middle Eastern backgrounds—are living on Long Island. Great Neck, in particular, is home to a very large Iranian/Persian community. While some traditional Jewish delicatessens are closing, new types of restaurants are opening that cater to a new international palate. The Five Towns area, Long Beach, and Great Neck in Nassau County are home to a large modern Orthodox community with supermarkets and various shops catering to their needs. In Southampton, an *eruv* has recently been established, indicating a significant Orthodox community. The Chabad movement is opening an increasing number of synagogues throughout Long Island. As in the past, Jews continue to support ideological, educational, and relief organizations.

The Jewish community of Long Island continues to thrive with an evolving identity.

BIBLIOGRAPHY

Gerard, Helene. "And We're Still Here." *100 Years of Small Town Jewish Life*. Remsenburg, NY: Hier Publications, 1982.

———. "Long Island Studies Council." Previously published as "Needles and Thread—Jewish Life in Suffolk County." *Suffolk County Division of Historic Services*. November 1982.

_____. "Yankees in Yarmulkes: Small-Town Jewish Life in Eastern Long Island." *American Jewish Archives* 38 (1986) No. 1: 22–55.

Kreisel, Martha. "From Orchard Street to Sunrise Highway: The Establishment of Jewish Communities in Nassau County: 1897–1999." *Nassau County from Rural Hinterland to Suburban Metropolis*. Edited by Joann P. Krieg and Natalie A. Naylor. Interlaken, NY: Empire State Books, 2000.

Long Island: Our Story. Melville, NY: Newsday, 1998.

Newman, Tobie, and Sylvia Landow, eds. *"That I May Dwell Among Them:" A Synagogue History of Nassau County*. Conference of Jewish Organizations of Nassau County, 1991.

Postal, Bernard, and Lionel Koppman. "Nassau and Suffolk Counties." *American Jewish Landmarks: A Travel Guide and History*. Vol. I. New York, NY: Fleet Press Corporation, 1977.

"Statistics of Growth." *Multiple Service to Jewish Families of Long Island*. Rego Park, NY: Jewish Community Services of Long Island, 1967.

Stern, Marc J. "The Social Utility of Failure: Long Island's Rubber Industry and the Setauket Shtetle, 1876–1911." *Long Island Historical Journal* 4, No. 1 (Fall 1991): 15–34.

United Jewish Appeal–Federation of Jewish Philanthropies. *The Jews of Long Island: A Tapestry*. New York, NY: United Jewish Appeal–Federation of Jewish Philanthropies, 1986.

INDEX

ABOUT JGSLI

The Jewish Genealogy Society of Long Island (JGSLI), established in 1985, is a leading and award-winning organization with approximately 250 members. Its mission is to encourage, educate, and develop resources for family history research. JGSLI can be found online at www.jgsli.org, providing organizational and research information, including award-winning YouTube videos. The monthly meetings offer professional speakers, research assistance, and genealogical instruction. Publications include JGSLI Online, a monthly electronic digest ,and *Lineage*, a tri-annual online magazine. JGSLI is the recipient of three awards by the International Association of Jewish Genealogical Societies (IAJGS): the 2015 Outstanding Publication, for the YouTube channel; the 2014 Outstanding Publication, for *Lineage*; and the 2011 award for the International Jewish Genealogy Month poster, created by a member. JGSLI is a member of IAJGS, the Federation of Genealogy Societies of Long Island, and the Federation of Genealogy Societies. Many JGSLI members are international speakers and hold leadership positions in major genealogical organizations. JGSLI is celebrating its 30th anniversary. The current board of directors is Devorah Wang, president; Bonnie Birns, vice president of membership; Randi Zwickel-Patrick, vice president of programming; Fern Gutman, secretary; John Paul Lowens, treasurer; Nolan Altman; Ann Armoza; Mitch Cohen; Rhoda Miller; Renee Steinig; and Chuck Weinstein.

DISCOVER THOUSANDS OF LOCAL HISTORY BOOKS FEATURING MILLIONS OF VINTAGE IMAGES

Arcadia Publishing, the leading local history publisher in the United States, is committed to making history accessible and meaningful through publishing books that celebrate and preserve the heritage of America's people and places.

Find more books like this at
www.arcadiapublishing.com

Search for your hometown history, your old stomping grounds, and even your favorite sports team.